*Japan Color*

Chronicle Books • San Francisco

# JAPAN COLOR

Edited by Ikko Tanaka & Kazuko Koike

Editorial Supervision by Mitsukuni Yoshida

Library of Congress Cataloging in Publication
Data:
Tanaka, Ikkō, 1930–
    Japan color.
    1. Color in art—Japan. 2. Color—Japan—
Psychological aspects. I. Koike, Kazuko,
1932–II. Title.
ND1489.T36   1983    700′.952         83-7489
ISBN 0-87701-305-5  (Paper)
ISBN 0-87701-310-1  (Cloth)

First published in Japan by Libro Port Co., Ltd.,
Tokyo, 1982

Chronicle Books
870 Market Street
San Francisco, CA 94102

# Contents:

# Color and Design in Tokugawa Japan
## Haga Tōru*

### Awakening to a World of Blue

> Asagao ya
> ichirin fukaki
> fuchi no iro.

> Ah! The blossoming
> morning glory—
> deep pool of blue.

This poem by Yosa Buson (1716—83)** communicates an immediate sensation of refreshment and cool, particularly for older generations of Japanese. Much may be lost in the translation and one wonders if the poem can speak to a Westerner in a similar way, or whether it becomes in English simply a cryptic string of words.

The morning glory, as its name proclaims, blossoms with daybreak and fades as the sun rises. It flowers from midsummer to early autumn and is traditionally used by haiku poets as a seasonal term for autumn. The reason for this is that even in summer it blooms only in the cool early hours of the morning when the dew is heavy, a slender, trumpet-shaped flower in any of a wide range of colors. According to legend, its seeds were first brought from China for medicinal purposes in the tenth century. Japanese have a special affection for its shape, simpler even than the tulip, and for its fresh, bright colors. It began to be cultivated for pleasure after the beginning of the eighteenth century, just about the time of Buson, and is easy to hybrid, either for shape or color of its flower.

I call Japan of the 1700s an "age of naturalists," for peace throughout the country seemed to encourage a trend, among professionals and amateurs alike, for mania-like study and connoisseurship of the natural world. One of these many pursuits, among which the breeding and care of goldfish was particularly prominent, was the study and hybridization of the morning glory, and devotees of the time left many volumes on its cultivation and care. By the beginning of the nineteenth century in Edo (Tokyo before 1867), it became customary to hold a special market in the early mornings of summer

* The Japanese names in this essay are given in the customary Japanese order, last name first.

**Buson, who lived about the same time as Thomas Gray and Jean-Jacques Rousseau, was among the most outstanding haiku poets of the eighteenth century in Japan. Along with his predecessor Matsuo Bashō and his successor Kobayashi Issa, he is known as one of the three geniuses of haiku, a seventeen syllable form of poetry refined in the Tokugawa period (1603—1867).

at the Kishimojin Shrine, devoted solely to the sale of morning glory plants and seedlings. This "morning glory market" flourishes even today, a topic never overlooked in the newspapers and on television as the season rolls around. To this market come fishmongers, grocers, carpenters, teachers and policemen, all to buy a pot or two to place at their doorway or veranda or windowsill for the summer season. The more enthusiastic morning glory lovers save seeds from year to year, creating hybrids of their special favorites, with these humble pleasures enjoying the passing of each summer.

Just as the tulip is for the people of Holland the object of special affection, the morning glory has been for centuries past the inexpensive, humble symbol of summer in whose shape and color Japanese find some relief from the oppressive heat of the season. Lifted on slender tendrils of bright green entwining bamboo props, its trumpet-shaped carollas may bloom in pale pink, light purplish red, or even pure white with streaks of scarlet or blue. In some hybrids the flowers are even speckled. Quite unlike the thick-petaled tulip, it is a frail flower, blended of pale, simple hues as if from a watercolor brush. No other flower suits a Japanese summer morning better than the morning glory for its pure, uncomplicated beauty.

Among the many colors of the morning glory, perhaps the most closely associated with this flower is the color *ai* or indigo blue. Like the *fuchi no iro,* deep blue, used in Buson's poem above, it is the color of water that, cascading down a mountain over jagged rocks, eddies gently in a deep pool. The shape of the morning glory, like a glass that grows slender at its base, gives the illusion that the blue grows deeper the further one peers into its depths, as if gazing into the bottom of a cool mountain pool. Certainly Buson himself was inspired by such a morning glory, perhaps blossoming of a summer or early autumn morning on a vine entwined around some garden hedge. Fascinated, he must have felt the limpid blue of the mountain stream—soundless, cool and deep—as if rising literally out of the depths of the blossom. It is a poem that demonstrates admirably the special imaginative talent of the haiku poet for portraying in small things glimpses of a universe in another dimension.

On that summer morning, not fully awake, Buson found himself captivated by the world within the morning glory. At first caught in its spell, it was paradoxically that very vision that startled the poet to full awareness. Through the clever combination of sound and alliteration, the poem suggests the experience of awakening to the refreshing, cool qualities of the color *ai.*

**Summers of Indigo**

When the indigo blue or deep blue of the morning glory is somewhat paler, it is known as *ao* (blue) or *mizuiro* (sky blue). It is the color of an early summer or early autumn sky or of shallow lakes or rivers that mirror such skies. When blue is dark, it is known as *kon* (dark or navy blue). In some cases, when all strong light is eliminated and a shade of

purple added, it is *shikon* or purplish blue. The range of indigo hues is wide, from a bright blue, clear midsummer sky dotted with puffy white clouds and the billowing ocean that reflects it to the towering gray-blue silhouette of Mt. Fuji viewed from the adjacent seacoast, to the purplish blue of the delicate *nasu,* the small Japanese eggplant. All these hues may be found in the morning glory as well, all gradiations that Japanese associate with water, sky, and mountains, and the sensation of coolness they evoke.

The predominant color of Japan's lush natural landscape, indigo blue (*ai*), along with scarlet (*beni*), purple (*murasaki*), and green (*midori*), is among the favorite colors of the Japanese from ancient times. As a dye, the color *ai* was made from the *Polygonium tinctorium*, a plant of the same species as indigo. As early as the ninth century, the dye was available both domestically and as an import from China, and indigo dyeing (*ai-zome*) was widespread. It became a common part of the everyday life of the Japanese people during the Tokugawa period, especially from the beginning of the eighteenth century. In retrospect, the colors indigo, as well as brown, gray, and green, are so closely connected with Edo culture that we may even call them "Edo colors." The *ai* vegetable dye is well adapted to silk, hemp, or cotton fabric as well as to paper, and indigo dyeing often helps to set off the texture of a fabric or fiber, enhancing its inherent qualities. Silk attains a lustrous glow, hemp a hard sheen, and cotton, although it has no sheen, a soft depth that is gentle both to the eye and to the touch.

The studies of ethnologist Yanagita Kunio in *Momen izen no koto* [Cotton in Japanese Life, a collection of essays published in 1924] tell us that cotton was widely grown from the middle of the Tokugawa period. It came to be cheaply and widely produced all over the country, bringing many changes to the lives of ordinary Japanese. But, says Yanagita, cotton grew popular and its use spread rapidly for two reasons: first, it was not only cheap, but comfortable and practical for use in work clothing, and second, it could be readily dyed in a wide variety of colors.

At first cotton cloth was dyed in plain, unpatterned colors, but it was not long before dyers proliferated around the country and cotton thread was dyed in a variety of colors. Local farming women who did the weaving competed to produce unusual designs and stripe patterns. Samples were eventually made available in pattern books called *shimacho* which weavers collected for reference, at the same time devising original designs of their own so that in a comparatively short period of time, cotton print weaving and dyeing rapidly developed both in the realm of taste and as a technique. Weaving as a cottage industry became in some areas of the country an important source of additional income for farming households.

Whether a fabric was plain or striped and whether the stripes were vertical or horizontal, plaids or checks, blue, along with yellow and brown, was generally preferred for background or basic colors. *Ai* blue had many variations: dark blue, or light blue tinged with pink (*hanada-iro*), grayish blue (*onando-iro*), blue-black or bright purple.

Thousands of color variations were devised and woven in plain colors, varigated stripes or geometrical patterns, brightening the lives of Japanese during this long period of national seclusion.

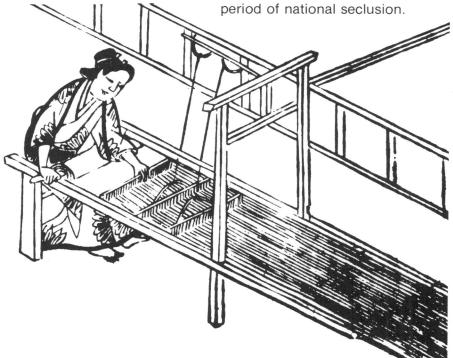

As a durable, stable color, *ai* was a favorite for the work clothing of farmers and fishermen. It was also the color of the heavy, sectioned curtains of cotton called *noren* hung at the entrances of the shops in Edo, Osaka and other major castle towns. The crested jackets, kimono, and aprons of shopkeepers and their assistants were almost always of dark blue *ai-zome*. Carpenters, plasterers, craftsmen, artisans, even firemen wore *hanten* jackets or happi coats or *haragake* (waistcoats) of this heavy, durable and comfortable cotton cloth, dyed in dark *ai* blue. When brand new, they were prized for the fragrance of the dye, when worn, a slightly thread-bare, mellow tone was testimony to their comfort and durability.

On *hanten*, the shop name or trademark, or in the case of firemen, the name of the firefighting team to which they belonged, was usually emblazoned in bold characters across the back, and artfully complemented with a geometric pattern printed across the waist. Men wore these garments with style and pride at being associated with the group or shop known by the symbol printed on their backs; they strove to achieve a manner and attitude befitting the aesthetic known as *iki*, which was closely associated with style and design in fashion. *Iki* meant a neat, stylish and smart appearance accompanied by a manner of pride, verve and crisp briskness. It was the distinctive aesthetic of the Edo townspeople and the definitive measure of character.

It was the habit of Edo men, and their wives and daughters and sweethearts as well, after a hard summer day's work, to don a *yukata* (cotton kimono) while relaxing in the evening hours after going to the baths. This garment was intended for comfort and, in its proportions and color, it was the embodiment of the tidy attractiveness and simple lines which were the fashion in Edo. In many ways it had to be. An entirely different genre of fashion from the Western nightgown or negligé, the *yukata* was cut on straight lines like other types of kimono, and is always of unlined, cotton fabric. For this reason, it is easily starched to a crackling crispness, which gives the shoulders and sleeves a cool, clear-cut look even when wrapped around the body.

Most *yukata*, moreover, were traditionally dyed in deep *ai* blue. This held true for both men's and women's *yukata*, and myriad designs—stripes, checks, realistic figures of

birds, waves or wild flowers, Chinese or phonetic characters of Japanese ortho-graphy, or with all sorts of clever realistic or abstract motifs freely combined—were printed in blue on a white ground or white on a blue ground. Ordinarily it was designs favored by popular Kabuki actors that set the trends in *yukata* fashion. The *yukata* of the men and women of Edo made up a veritable kaleidescope of design, a kind of kingdom of design of its own. Even as I write this manuscript, I notice at close look at my own *yukata*, that it is an indigo blue print (albeit with chemical dyes) of a variation on a design from the Tokugawa period.

Fresh from an evening bath, when a man donned a crisply starched *yukata* dyed with the colors of the Japanese landscape and tied it snugly with a slender obi, he cut a conspicuously neat figure of almost geometric forms. When a woman, too, rose from the bath and put on a *yukata*, its clean, elegant lines faintly betraying the curves of her body, it unfailingly bestowed on her an irresistable appeal that made men turn and take notice no matter how humble her charms. Not only in the Tokugawa period but even until just a generation before our time, Japanese turned to the *yukata* as the attire most pleasant and comfortable for the hot, humid evenings of summer. Wearing *yukata* itself was a special joy. And of course, it is pleasant not only for the wearer, but to the beholder for the sensation of coolness and refreshment it communicates. Two of Japan's leading modern haiku poets have immortalized the virtues of the *yukata* in poems like the following:

> *Yukata kite*　　　　　　　*Clad in yukata,*
> 　*shojo no chibusa*　　　　　*her slender figure*
> 　*takakarazu.*　　　　　　　*bespeaks the innocence of girlhood.*
> 　　*(Takahama Kyōshi)*
>
> *Yuhi aka-aka*　　　　　　*How Japanese!*
> 　*yukata ni misuki*　　　　　*The yukata's silhouette*
> 　*Nihonjin.*　　　　　　　*against the evening glow.*
> 　　*(Nakamura Kusatao)*

And when wearing a *yukata* of a hot summer evening, one could not be without an *uchiwa* or round fan, both to stir the breezes and banish the persistent mosquitos. These bamboo frame fans covered with paper were usually printed with designs using *ai* blue as the main color in order to accentuate the image of coolness. In time, the patterns decorating *uchiwa* and the manner in which they were used came to be differentiated for men and women and for persons of different ages. Perhaps the fetching little girl with the "slender figure" held such a fan printed with the love scene of some Kabuki hero and heroine:

> *E-uchiwa no*　　　　　　*Her's is a picture fan,*
> 　*sore mo Seijūrō ni*　　　　*and what's more*
> 　*O-Natsu kana.*　　　　　*it shows the lovers Seijūrō and O-Natsu!**
> 　　*(Buson)*

Then, too, one might chance to glimpse the figure of a woman holding a fan and sitting alone on her veranda in the evening before the lights are lit.

> Goke no kimi                Her beauty clasped by twilight
>     tasogaregao no              the widow
>         uchiwa kana.                gently wields her fan.
>         (Buson)

In the tortuous humid heat of summer, Japanese from Tokugawa times until as recently as twenty years ago had in defense to sleep under mosquito nets (*kaya*). These mosquito nets were made either of linen or cotton and most were indigo-dyed in a wide range of shades and hues. Stretched out beneath such a net, one waited for the breeze to waft through open doors and windows, or in its absence, fanned desperately until he drifted fitfully off to sleep. The blue of the mosquito nets was an attempt to create at least the illusion of coolness, for in fact they were quite oppressive inside. The poorer the family, the simpler were the pleasures this household necessity offered:

> Kaya tsurite                Let's put up the net
>     suibi tsukuramu              and make a green world of pretend
>         ie no naka.                in the house.
>         (Buson)

> Kaya no uchi ni              What a delight,
>     hotaru hanashite            to set free a glimmering firefly
>         a-a raku ya.              in the net!
>         (Buson)

Haiku is a genre of popular poetry rare in the world for recording such mundane details in the lives of ordinary townspeople throughout the four seasons and the feelings they engendered.

The people of Edo, upon awakening in the morning, might go out to a water basin at the end of their veranda to wash their faces, gazing sleepy-eyed at a vivacious morning glory, but it was not a washcloth they slung over their shoulders but a long, narrow piece of thin cotton fabric called a *tenugui*—and this, too, printed with designs or lettering in *ai* blue on a white ground.

> Asagao ya tenugui          Methinks the morning glory
>     no hashi no                resents the rival blue
>         ai o kakotsu.              of my tenugui fringe.
>         (Buson)

Buson's morning glory must of course have been *fuchi no iro*, the deep, clear blue mentioned in the poem at the beginning of this essay. The poet imagines that the flower complains that its blue is matched by the color of the *tenugui* he is using to wash his face, rivaling its own beauty.

Like the *yukata*, the *uchiwa*, and the *furoshiki* (wrapping cloth), no one knows who invented these indigo printed *tenugui*, but from the mid-Tokugawa period to very

recent days, it was an indispensable article of everyday life among the Japanese. To wipe away perspiration, cleanse the face, use in the bath—it served conveniently as both handkerchief and towel. But, even more, it became a form of headgear, folded, twisted and coiled in ingenious and numerous ways. Fashions of wearing the *tenugui* were myriad, each expressing the trade or even the mood of the wearer—a message others could invariably read at a glance tightly twisted and wrapped around the head with the knot at the side, the ends erect was the mark of the cheery fishmonger; draped like a triangle over the front of the head and tied behind—a newspaper boy. Spread open from the back of the head, brought forward and tied under the nose—a thief. Wrapped around the hair at the back of the head and tied in a bow over the forehead—a nursemaid. A woman who draped a *tenugui* open over her hair and took one end shyly in her teeth might be strolling with her handsome lover, who in turn covered his head completely, tucking in the ends jauntily at the right side. Folded lengthwise in a long strip, bound across the forehead and tied behind, was the hallmark of the samurai determined in battle. This style, called the *hachimaki*, was adopted by the *kamikaze* suicide pilots who bombed American warships in World War II. Today, it is often tied on by determined students studying to pass the entrance examinations to the university. Groups of demonstrators at a union rally also fancy this style.

It was the Kabuki actors who invented and refined the art of wearing the *tenugui*, and even today, *rakugo* comic storytellers, using this universal item of daily use and a single folding fan, can recreate almost any conceivable gesture and attitude. The *tenugui* became such an inextricable part of the national costume in the Edo period that people had mastered the art of displaying the *tenugui*, both consciously and unconsciously, so that its floral pictoral, lettered or stripe designs were always set off to advantage.

## Japan's Tricolor

Through the eyes of haiku poetry, at least, it would appear that, for Japanese of the Tokugawa period, their summer days began and ended with *ai* blue. But while blue was a color especially loved in summer, its appearance was by no means restricted to that season alone. Shop employees and artisans wore their dark blue *hanten* all year round, making its simple lines and color a part of every season.

The omnipresent blue was even noticed by Lafacadio Hearn, one of the earliest writers on Japan, who arrived from the United States by way of Canada in early April 1890. It was a lovely spring day with a clear view of snow-capped Mt. Fuji in the distance. Hearn mentions blue in his first impressions of the Yokohama landscape:

> *Elfish everything seems; for everything as well as everybody is small, and clear, and mysterious: the little houses under their blue roofs, little shopfronts, hung with blue, and smiling little people in their blue costumes.*

Over the city lay "an atmospheric limpidity extraordinary, with only a suggestion of blue in it." The jinrikisha driver Hearn hired moved quickly and briskly, attired in a

wide-sleeved, short jacket of dark blue and dark blue *momohiki* (close fitting trousers); he wiped away the sweat with a sky blue *tenugui* printed with a white sparrow and bamboo pattern. And, perched in the jinrikisha, Hearn observed the town around him:

> *'Tis at first delightfully odd confusion only,... through an interminable flutter of flags and swaying of dark-blue drapery, all made beautiful and mysterious with Japanese and Chinese lettering. ... You observe that the same rich dark-blue, which dominates in popular costume, rules also in shop draperies.*
>
> *(from "My First Day in the Orient")*

It must have seemed to Hearn that he had wandered into a diminutive kingdom of indigo and dark-blue. It was the end of the nineteenth century, nearly forty years after the country had reopened to the world after its long period of seclusion, but the color preferences which had become established in Japanese life were not easily changed. As Hearn himself goes on to add, "there is a sprinkling of other tints— bright blue and white and red," and indeed Japanese lives were rich with many colors besides those of blue. Throughout the four seasons, there was green and brown, gray and black, gold and silver and red and white, used in all aspects of clothing, food, shelter, as well as for ornamentation and implements and every imaginable item of daily life. However, these colors were not what we call today "primary colors," and except for festival and other such ceremonial occasions, colors were rarely used alone. The articles of everyday life: kimono, fans, covers for books, even playing cards, combined several hues, producing an effect both striking and elegant. Almost every color was composed of some measure of gray, blue, or red, or toned down with brown. As mentioned above, the variations of these intermediate colors, some representing the most subtle differences of shade, were almost infinite, and in themselves constitute a core aspect of aesthetic taste in the Edo period.

Today, save for a small number of specialists in cultural history or the history of colors, few can distinguish and name these traditional color categories, most of which were created by the combination of natural vegetable dyes. Still, even modern Japanese feel an instinctual attraction for the colors of Edo period artifacts, recognizing in them the qualities of *shibui* (rich sobreity) or *iki* (refined smartness).

Throughout the two-hundred fifty years of the Tokugawa period, Japan withdrew into seclusion, continuing contact with other countries only through limited trade with the Dutch at the factory in Nagasaki and on a very small scale with the Chinese. During these two and a half centuries of complete peace, Japan's unique culture matured like a ripening fruit, and at the core of that culture this small universe of intermediate tints emerged spontaneously. Accustomed as they were to the soft Edo colors with their exceedingly and sometimes amazingly subtle differences in wave length, the people of Tokugawa Japan undoubtedly found the flags that began to fly in Europe and the United States around the same time, like the French *tricolore* and the American star spangled banner, either unattractive or glaring in coloring. In fact, in 1853, the year

Japan enforced the opening of the country, a Bakufu governor involved in negotiations with the Western powers wrote, "the ships and flags we see in the harbor are too dazzling to look at."

Still, at just about the same time that the Republic of France created the *tricolore*, a three-colored banner of Japan's own made its appearance. It was, of course, not a symbol of ideals like *liberté, egalité, fraternité*, nor even representing the spirit of the Japanese *Yamatodamashi*. The tricolor of the world of entertainment and diversion, it was the Kabuki theater curtain, consisting of broad stripes in hues of green, brown and black. These colors, symbolic of the Kabuki theater which played such a central role in the culture of the Tokugawa period, were typical of the neutral tints that epitomized Edo taste. Composed of several colors subtly combined, they are rather difficult to describe. The green is based on the color *moegi*, a neutral tint corresponding to the green tinged with yellow color of onion tops as they sprout, and slightly darkened by the addition of gray so that it is more like strongly brewed green tea. The orange, originally a color made from the tannin of the persimmon is again mixed, with red and a tinge of black, making it a subdued brown. Even the black is not simply black, but a deep blue infused with purple and black.

These three tints in a striped design take Japanese instantaneously back to the Edo period, inspiring the impulse to don a kimono and set forth for the Kabuki theater or go out to eat *sushi*. Even today at the end of the twentieth century, where there is something of special significance in Japanese culture, there you will find these subtly suggestive colors. If ever Japanese should come to think their national flag—the red rising sun on its white background—too aggressive, certainly few would object to a change to these three Edo colors. (I am sure, however, that the printers and dyers of the world would tear their hair in attempting to reproduce these complex tints!)

## Arts, Crafts and Life in Japan

Just as colors developed by generations of nameless dyers became the symbols of the Kabuki stage, by the same token, the favored colors of famous Kabuki actors had a way of becoming the instant fashion not only among Edoites but throughout the secluded island nation. A very early example of this cultural phenomena involves a favorite brown color of the actor Segawa Kikunojō II (whose haiku name was Rokō and who acted in Edo in the 1760s and 70s) a player of female roles and a contem-

porary of Buson. It was a somber brown infused with dark green which came to be called Rokō brown, and it was popular throughout Japan until as late as 1820. From Rokō's time on until the end of the Tokugawa period, the favorite browns and blues of generations of popular Kabuki actors, along with many kinds of striped, tied or finely-patterned designs, became a familiar part of Japanese society, in every region and every social class. This influence was profound in popular attire, in particular, but also in the color and design of all kinds of implements, ornaments, and toys that were part of daily life.

Moreover, art and literature played a vital role as a medium of interaction between Kabuki and the lives of townsmen, with each generation growing increasingly popular. In the Genroku period (1688—1704), it was the literature and writing of Saikaku and Chikamatsu as well as the Kōrin school of painting that supported the development and refinement of *jōruri* singing and the bourgeois theater, but from the end of the eighteenth century through the first half of the nineteenth century, ukiyoe prints and popular literature played a vital role in familiarizing ordinary people with Kabuki costumes, plays and acting styles. Looking at the color prints of ukiyoe artists from Harunobu and Kiyonaga, Utamaro, Sharaku, and on to Hokusai, Hiroshige, Kuni-yoshi, and Eisen, it is clear that they portrayed the favorite colors and designs of popular actors, further stimulating their popularity. But more than this, they never seemed to tire of portraying the images of famous geisha of the pleasure quarters and ordinary men and women of the town whose attire reflected the latest fashions. And of course, aside from these busy, gay circles, the woodblock print artists painted townspeople of all ranks, as well as artisans and farmers, working, travelling and playing throughout the seasons and in both city and countryside, making full use of Edo colors—deep blue, red, green, and brown in all shades and hues—and rendering all these scenes with lively, exquisite lines.

As you know, when avant-garde painters and art lovers of Europe first discovered the beauties of ukiyoe, they were ecstatic. Their enthusiasm for these prints led them to seek deepened understanding of Japanese arts as a whole, discovering there not only novel ways of treating space and color, but finding to their admiration that between art and life in Japan there existed a rich and lively interaction.

A few Japonisants at the end of the nineteenth century discovered that in Japanese culture the landscape and climate, painting, poetry, crafts and architecture, designs of all kinds as well as the theater and daily life all interacted in a single rich sphere of taste, by which I mean "civilization." Their observations, moreover, basically reflected an accurate understanding of Japanese culture in the Tokugawa period. The first English minister to Japan, Sir Rutherford Alcock, who arrived shortly after the opening of the country and saw and experienced "Japanese civilization" for himself in the middle of the 1860s, recorded his impressions faithfully in a vivid account, *The Capital of the Tycoon: A Narrative of Three Years' Residence in Japan* (London and New York,

1868). And Van Gogh, when he visited Arles in southern France in 1888, proclaimed that the clear bright skies of that part of the country and the sparkling of the blue waters reminded him of the exoticism of the "beautiful country" of Japan. He believed that Japanese painters were akin to philosophers who engaged in the humble study of a single blade of grass and sought in it understanding of the world of nature, the seasons, the rural landscape, and even human beings. This was also just about the time Lafacadio Hearn first thought of travelling to Japan.

Most likely Van Gogh's view of Japanese art was influenced by an article that appeared in the first issue of *Le Japon artistique* (1888-91) published in Paris. The editor of this journal was the German born Samuel Bing, an art dealer specializing in *japonaiserie* and a leading promoter of the movement, and in the first issue he wrote, under the title "Programme," the manifesto of Japonisme:

> The Japanese are poets moved and inspired by the great spectacle of nature and attentive observers of the familiar mysteries of a world of exceeding minuteness. They learn geometry from the spider's web, take decorative motifs from the tracks of a bird across the snow and receive inspiration for curved designs from the ripples of wind on the water. In short, they believe that the fundamental elements of all things are to be found in nature. They believe that there is nothing in the world of creation that is not suited to the high ideals of art. Even a single, small blade of grass. If I am not mistaken, this is the most important and the most profitable lesson we can learn from these people.

In the second issue (June 1888), art critic Louis Gonse went on to praise "le génie des Japonais dans le décor" and in every subsequent issue, a wide range of French, English and German authors wrote on Japan's art and artists and traditions of architecture, theater and poetry, on pottery, combs, swords and *netsuke* and on all kinds of objet d'art. Thus *Le Japon artistique* became a journal of studies on Japanese culture of the highest order, and the appreciation of these writers of the arts, crafts and life of Tokugawa Japan was by no means mistaken. This is even confirmed by our brief look at poems about morning glories, work clothing and *yukata* of *ai*-dyed cotton, *uchiwa* fans and *tenugui* as well as at the colors and designs of of Kabuki and ukiyoe.

In Japan at the end of the twentieth century, it is naturally not as easy to achieve the harmony that results from interaction between nature and the life of the arts as in the Edo period. However, the experience and legacy of the past is more than simply a thing of the past, for it survives even today in our sensibilities, thinking and very "art of living." As long as the core nature of the Japanese, too, survives, contemporary Japanese graphic design will continue to demonstrate, in boldness of design, freshness of form and subtlty of color, and in compactness and efficiency in everything from cars to cameras, the sustained appeal of the Japanese sense of beauty.

August 1981
(translated by Lynne E. Riggs)

*Vitality and Purity*————

Kōhaku: Red and White ——— the special combination of these two colors is pronounced as one word in Japanese. *Kō* means red, while *haku* translates as white. Their use together immediately signifies happiness and celebration to the Japanese viewer. The opposite combination, black and white, stands for mourning and cheerless occasions. It is popularly felt that red is a color representing life and vitality. It reminds us of the blood coursing in our veins, and of the sun: a symbol of energy, radiating its vitalizing life-force into human beings. White has long been regarded as the color of the gods; pure and unsullied, it reflects the existence of this sacred glory. We can see, therefore, in the combination of these two fortuitous colors, red and white, the symbolic linking of life's power and everlasting exaltation.

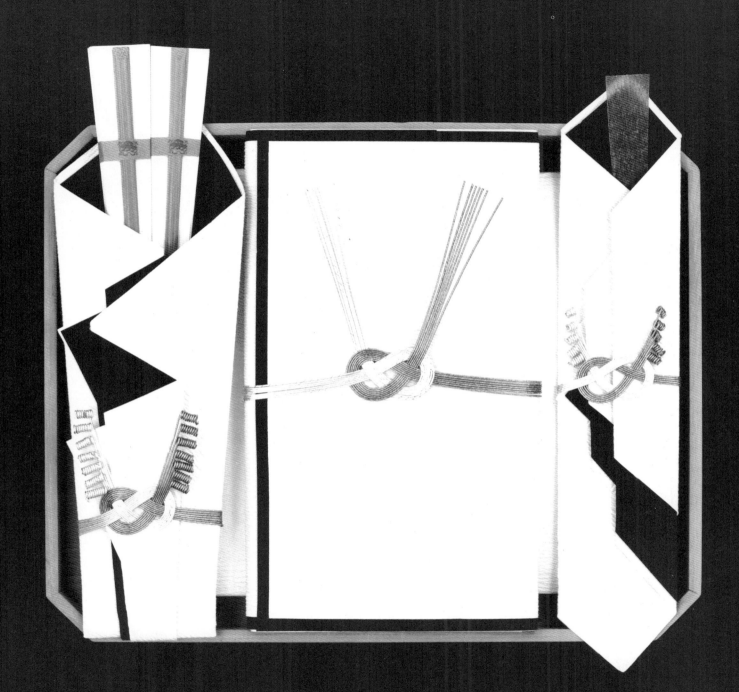

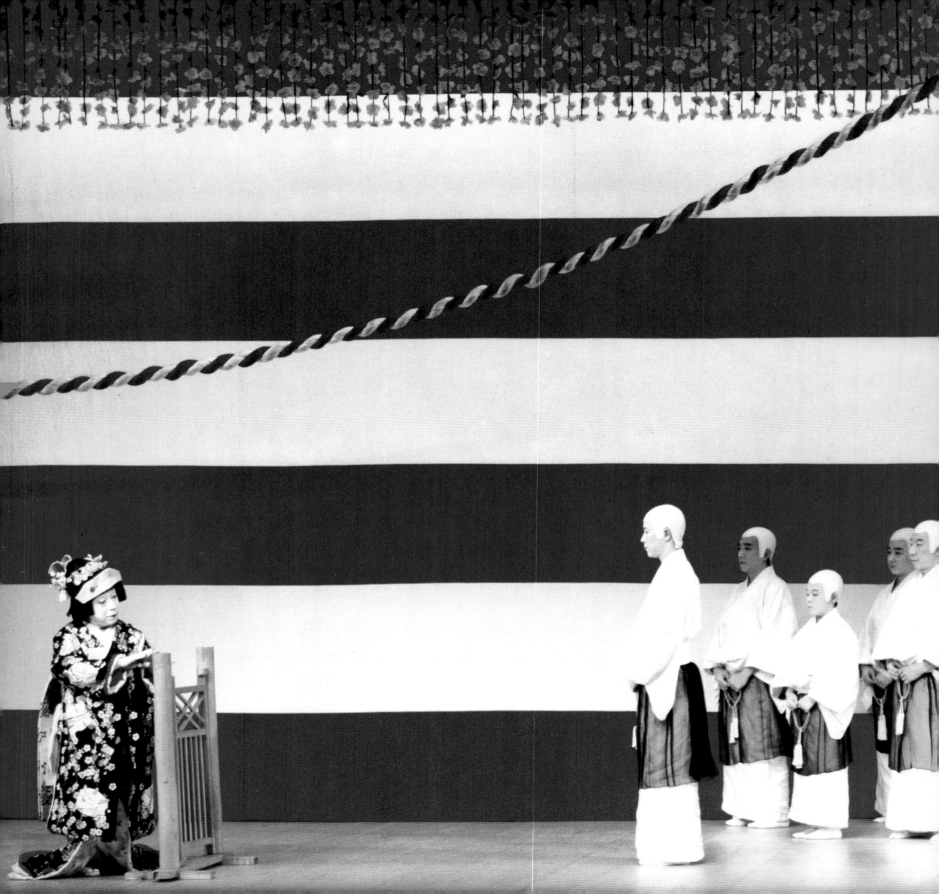

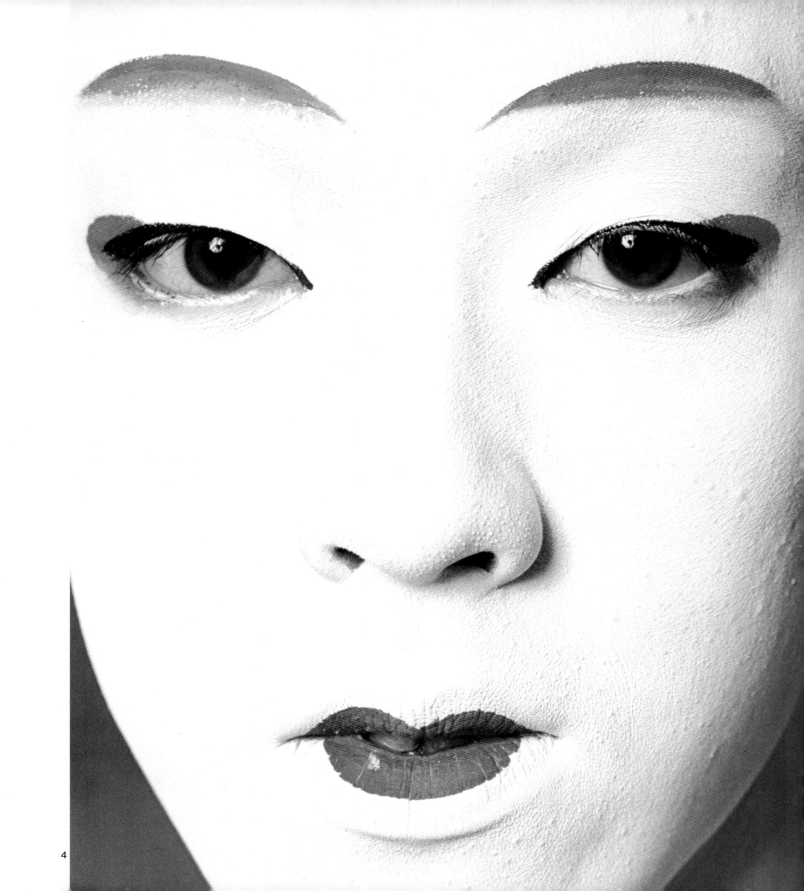

4

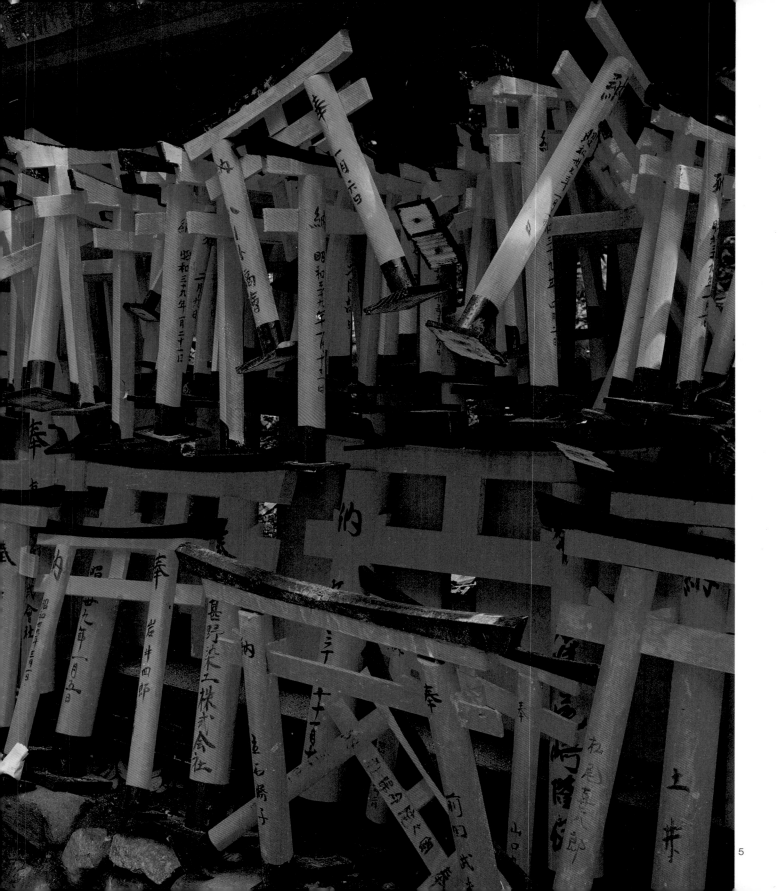

5

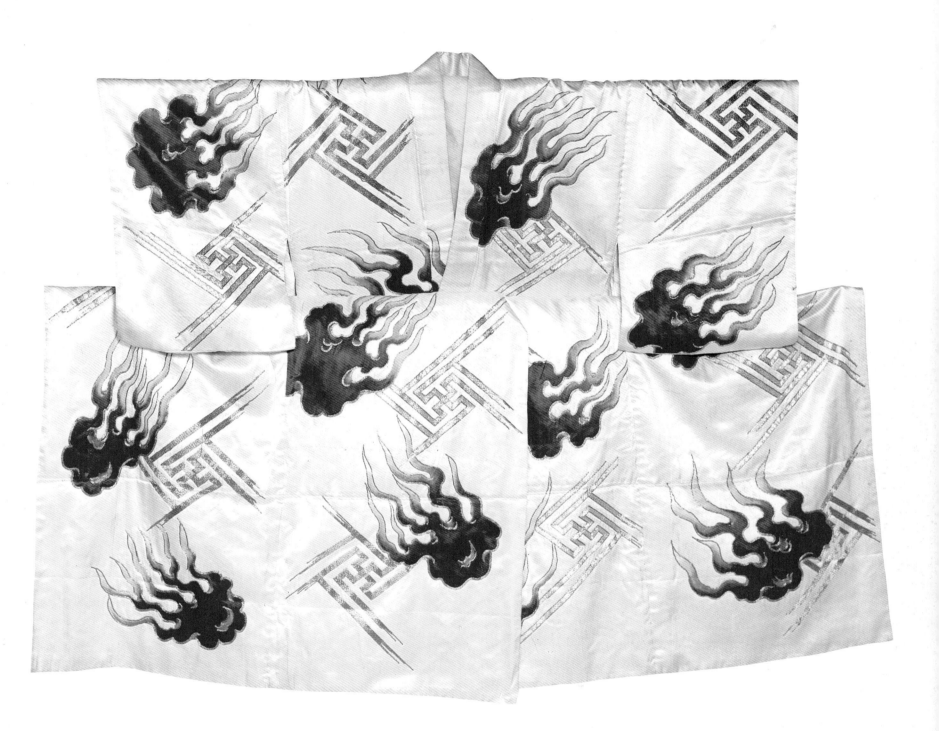

6

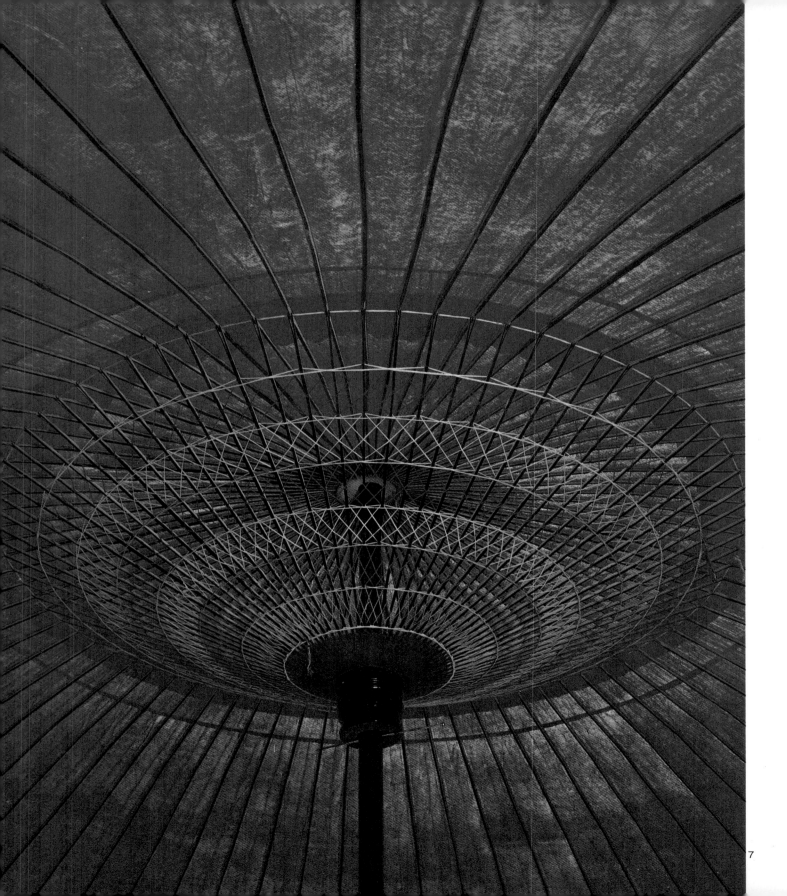

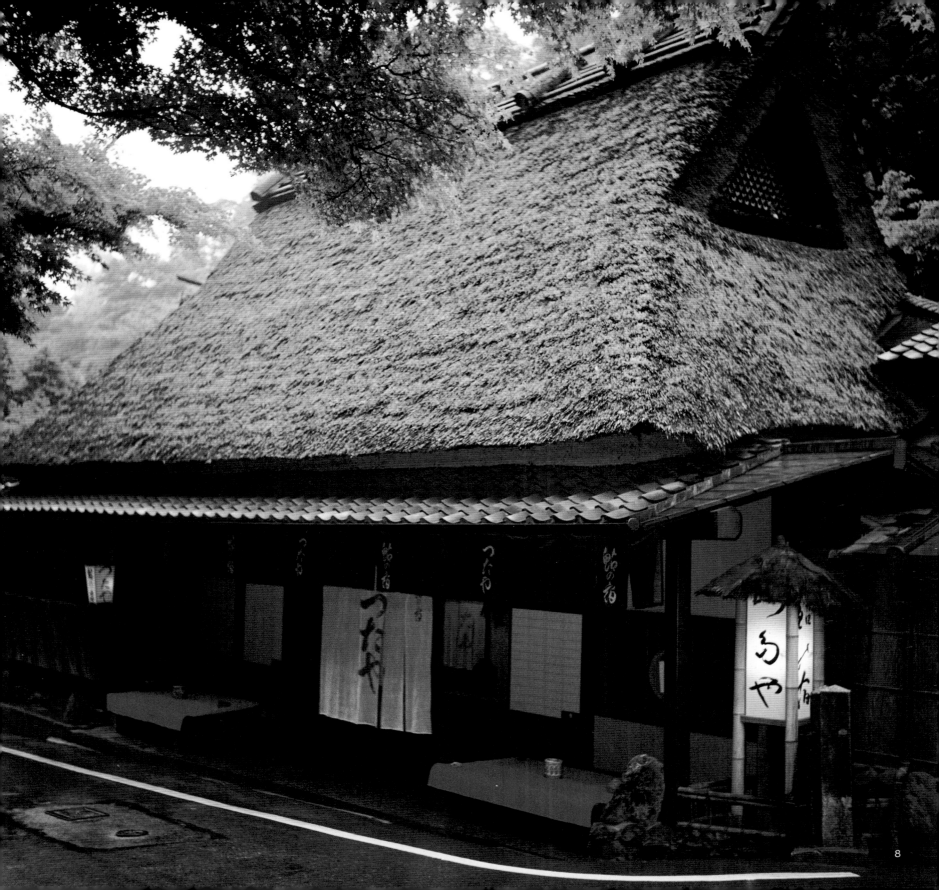

8

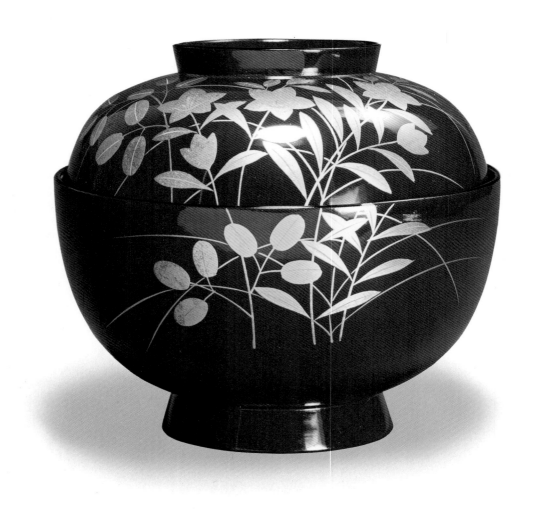

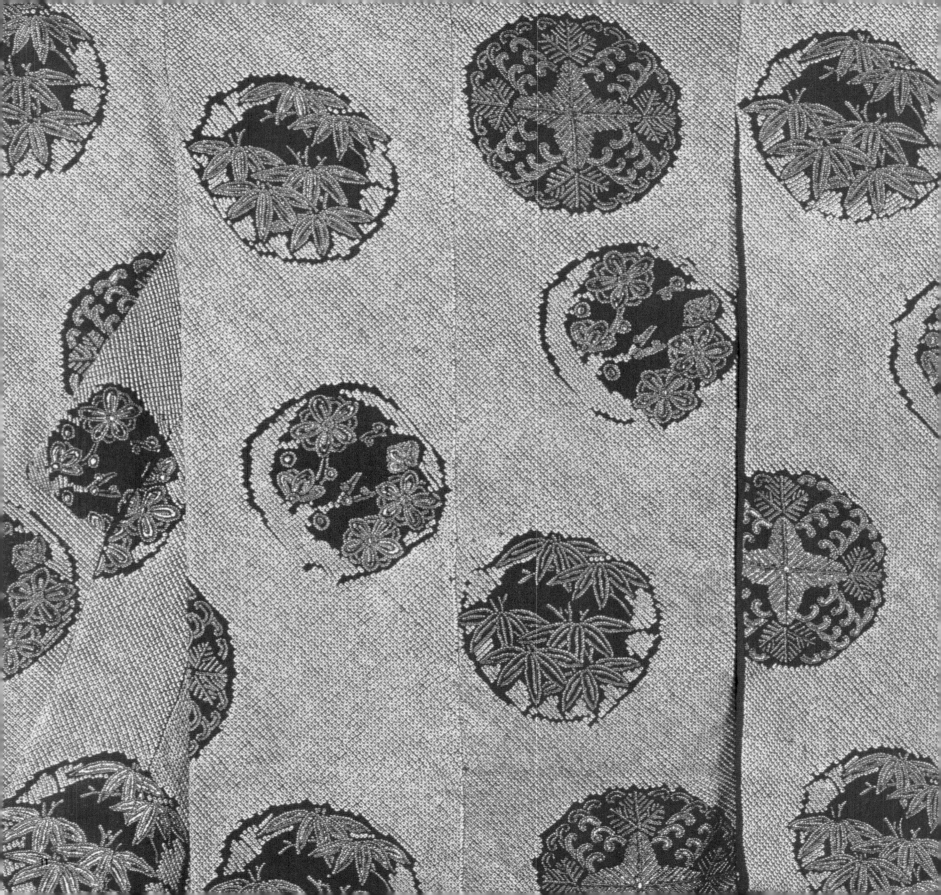

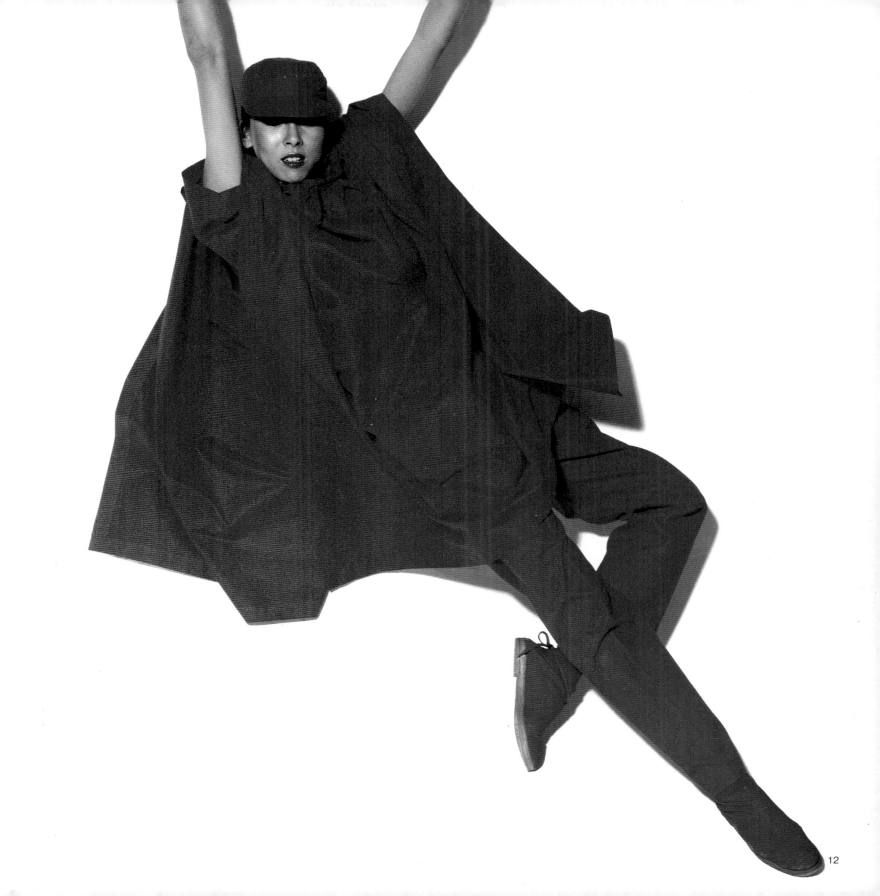

12

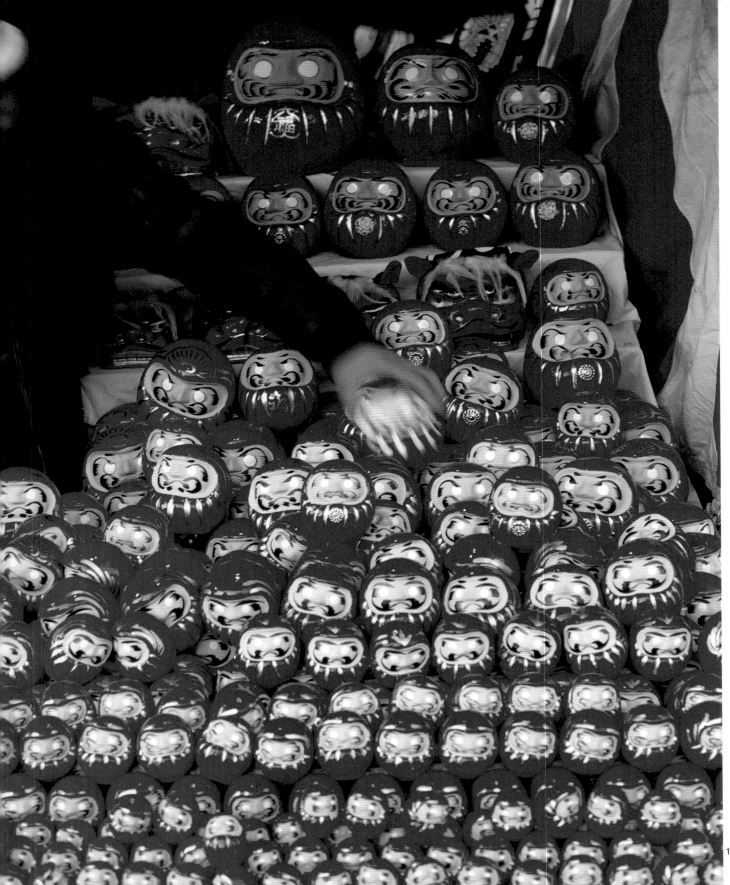

16

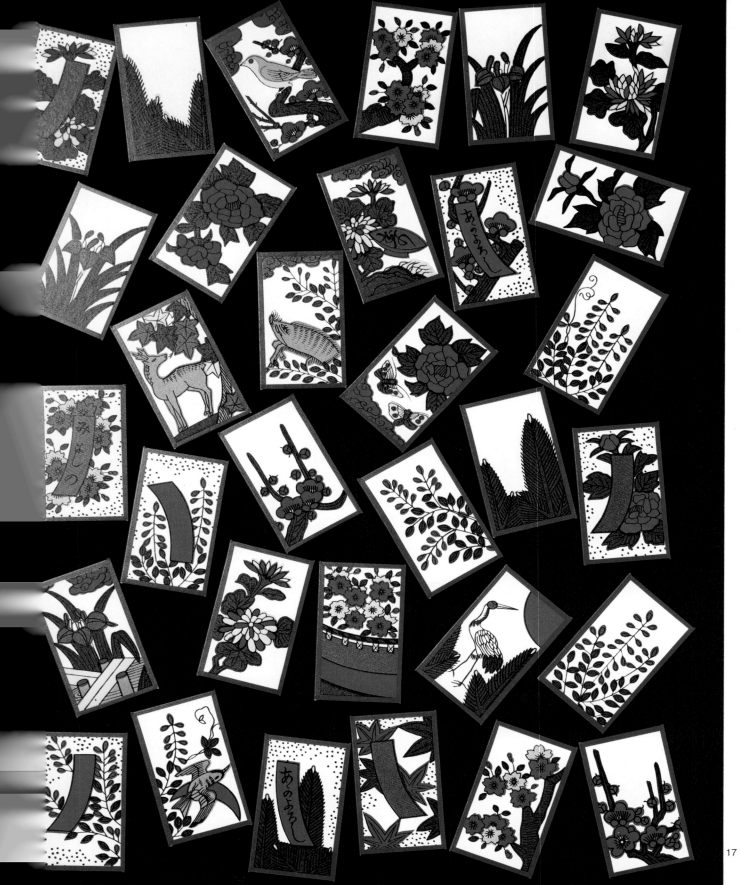

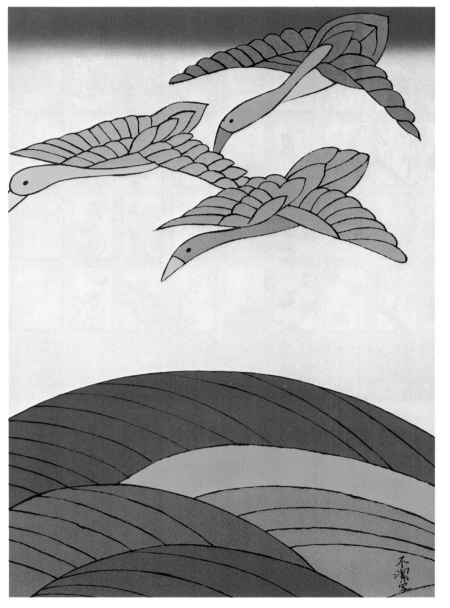

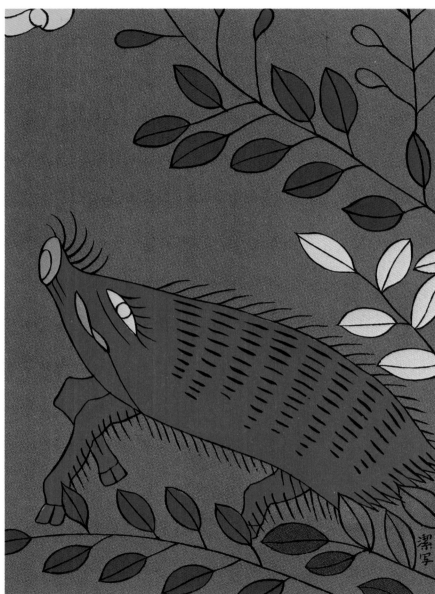

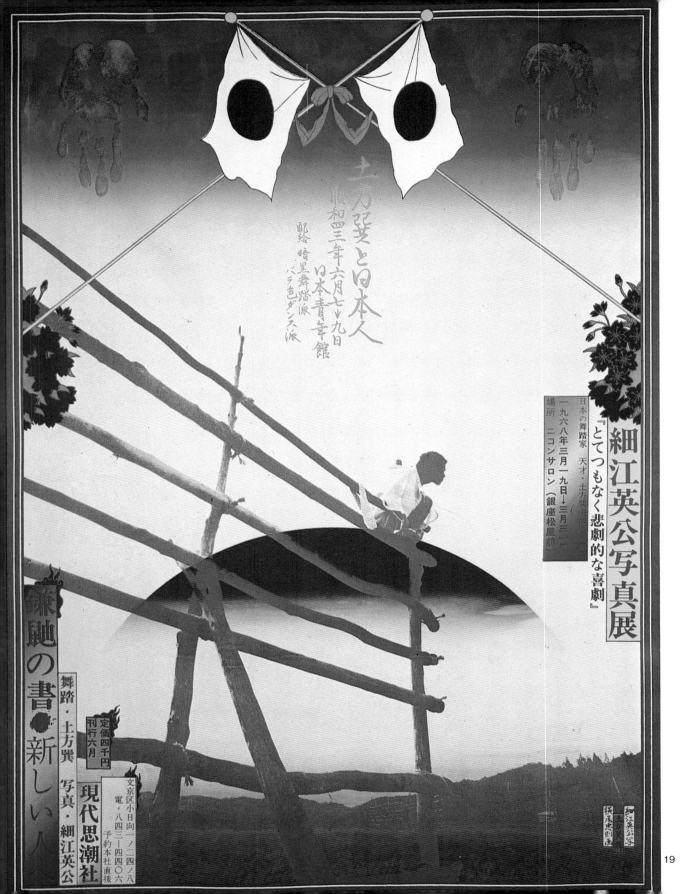

細江英公写真展

『とてつもなく悲劇的な喜劇』

日本の舞踏家　天才・土方巽を撮る

一九六八年三月一九日→三月三一日
場所　ニコンサロン（銀座松屋前）

土方巽と日本人

昭和四三年六月七→九日
日本青年館

舞踏　暗黒舞踏派
踊絵　バラ色ダンス派

鎌鼬の書●新しい人

舞踏・土方巽　写真・細江英公

現代思潮社

定価四千円
刊行六月

文京区小日向一ノ二四ノ八
電・八四三一四四〇六
予約本社直接

19

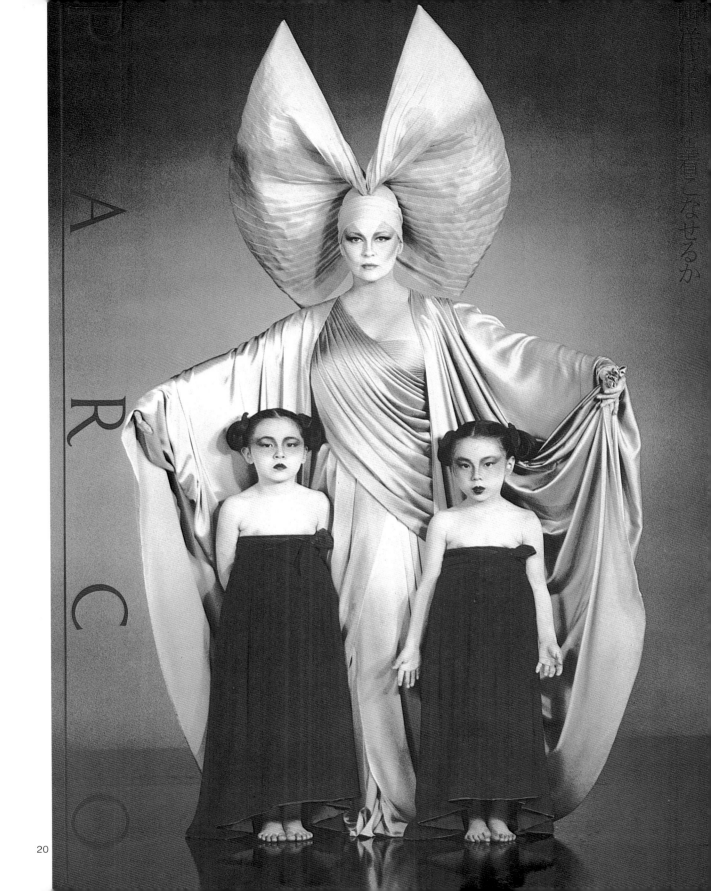

時代は今を看んなせるか

20

21

Midori: Green ——— the color of eternal life, as seen in those evergreens that never change their color from season to season and are regarded as sacrosanct: the pine, cedar, and *hinoki*. In the word *midori*, both trees and vegetation are implied. Verdurous greens are always around us; from the traditional Japanese residence, to the highly treasured garden; and includes our eating habits, which are really based upon a vegetable diet. In other words, it may be said that one characteristic feature of Japanese culture can be found in our fusion with nature. And, just as the greens that surround us are varied, so are the varieties of life and spirit which dwell within each of us.

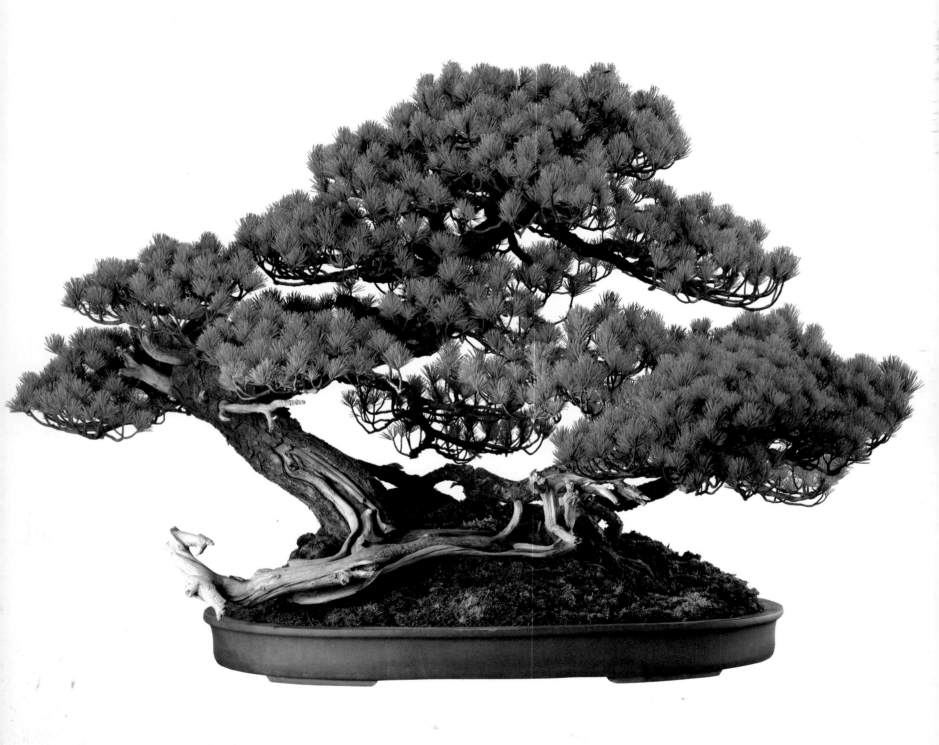

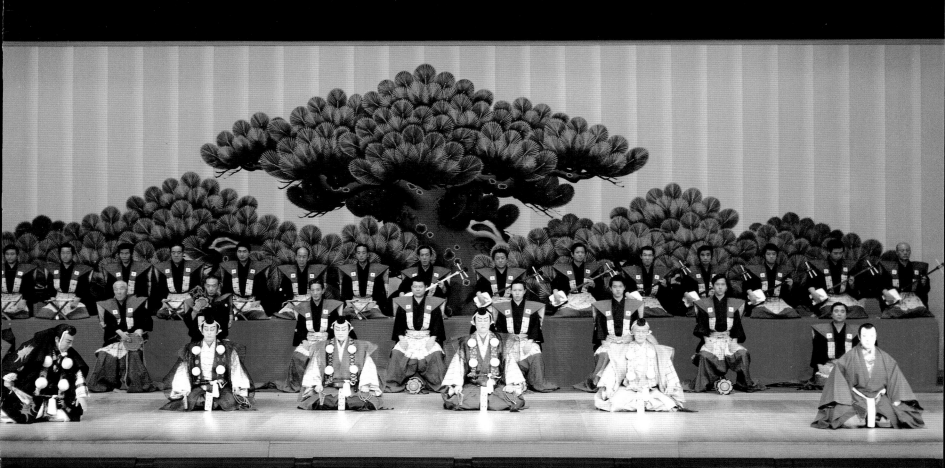

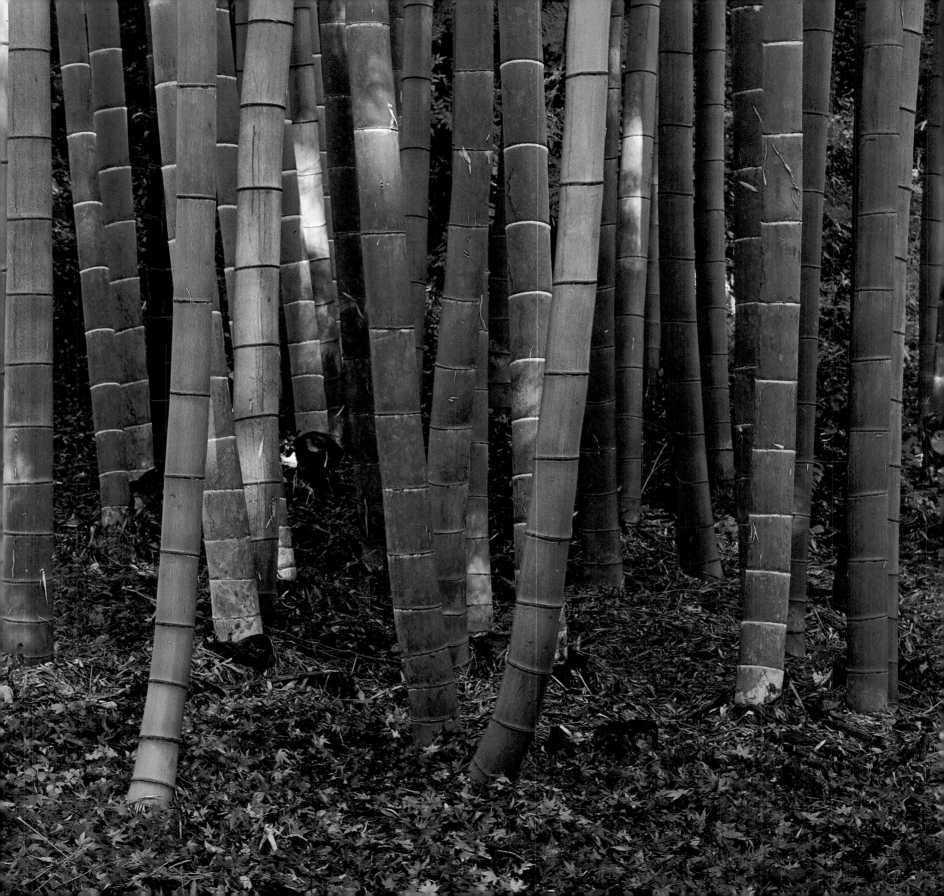

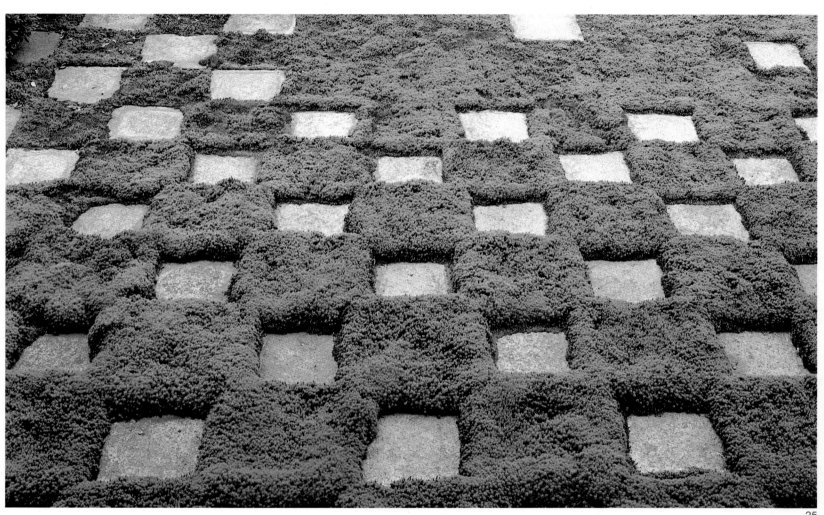

25

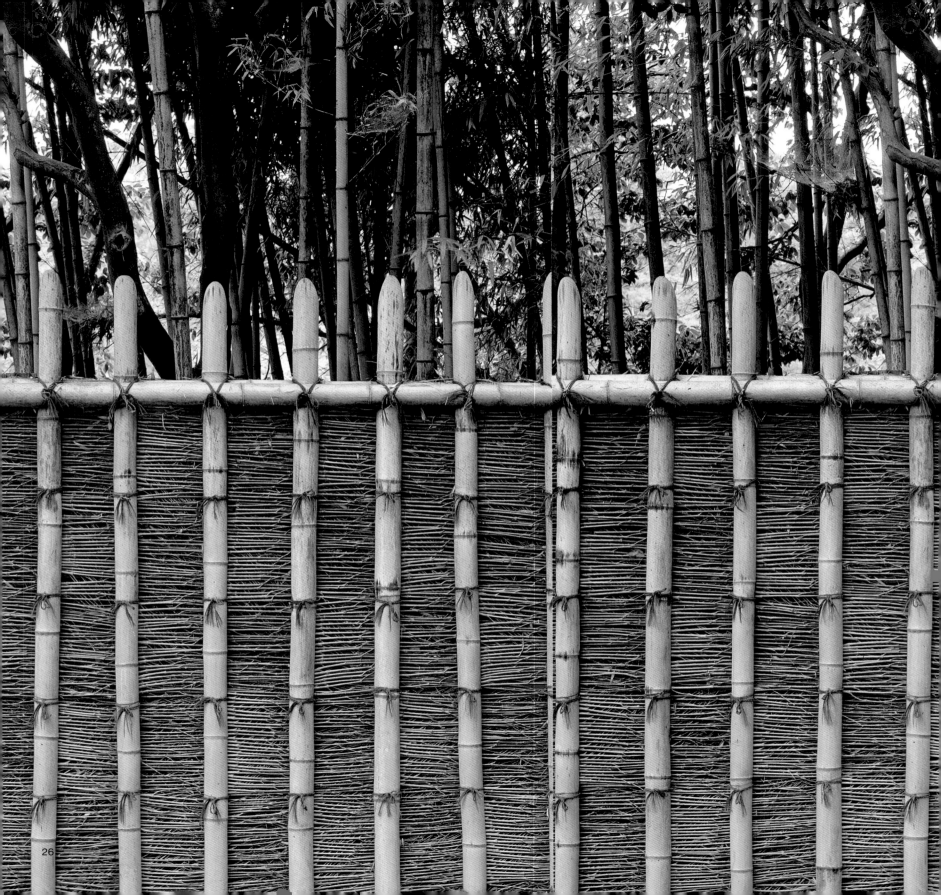

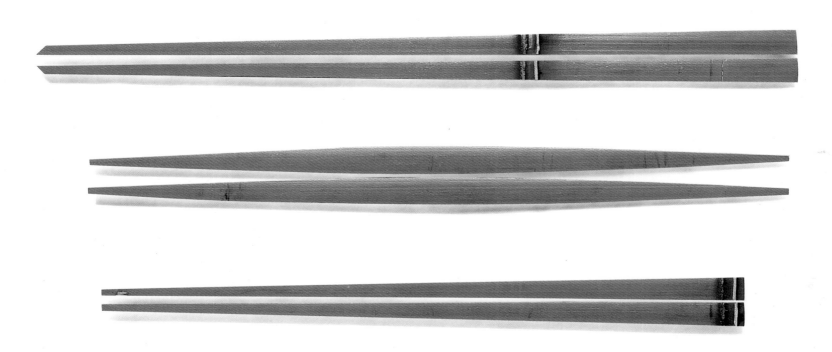

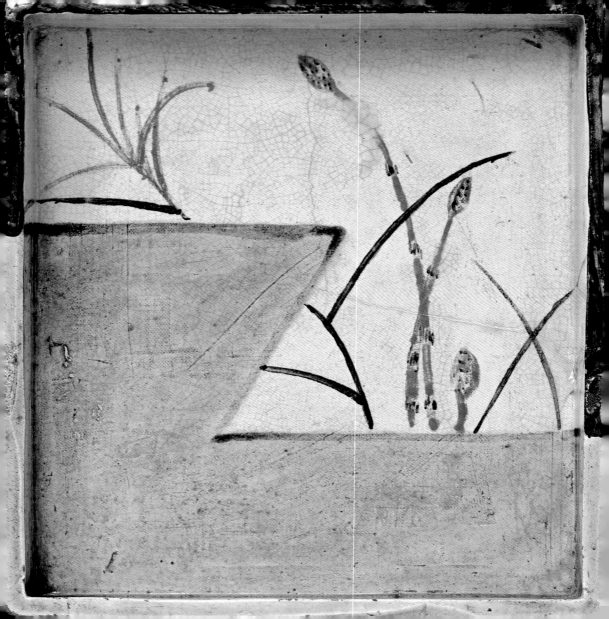

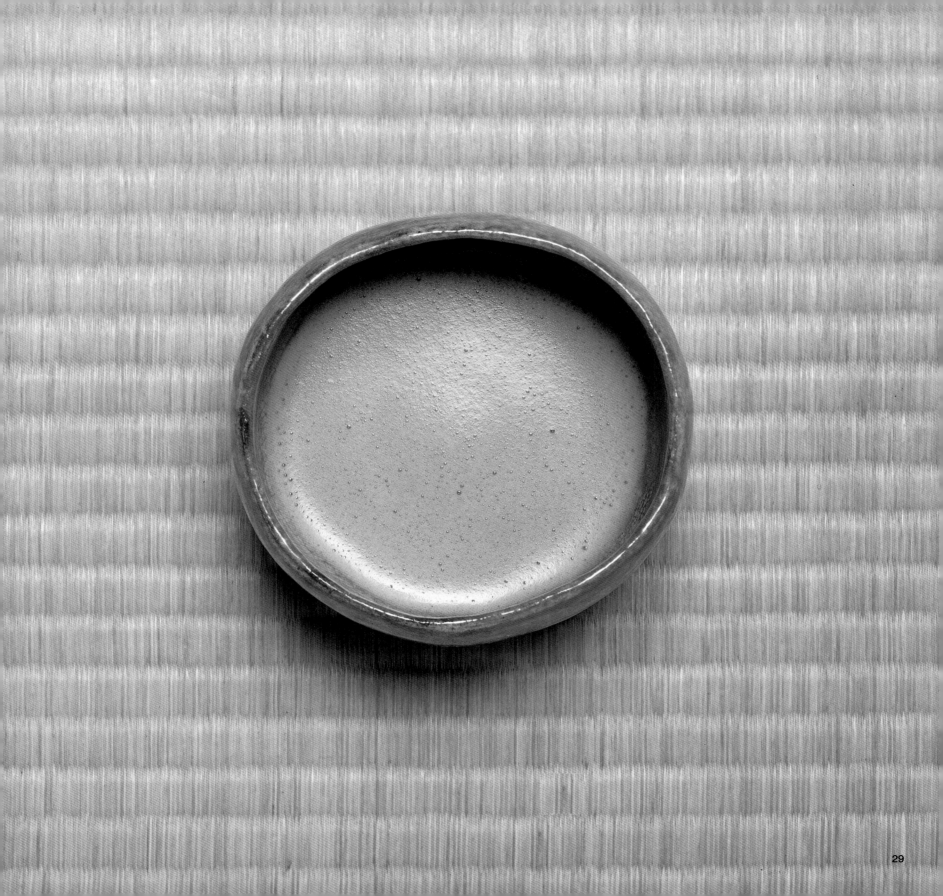

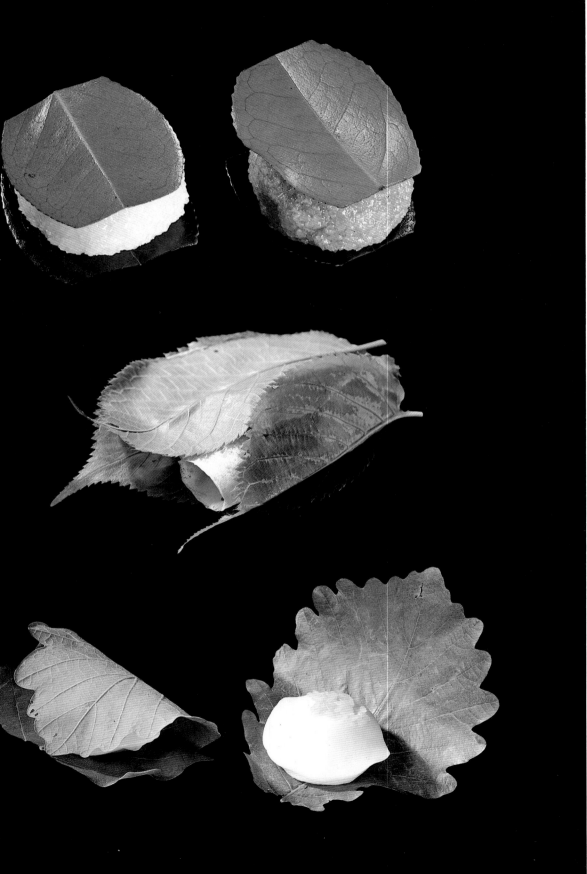

Ai: Blue ─── a particular shade of Japanese indigo blue, it mirrors the color of the vast ocean surrounding the Japanese islands. It was by means of the sea that our ancestors came to this land long, long ago. Moreover, the sea is an important productive world for us, supplying an abundance of food. In addition to the earth, the sea is a maternal source. This beautiful blue that reminds us of our ancestry through the sea, has, historically, always been the color of the people. Without a doubt, our so-called *ukiyo-e* blue has been the most duplicated; seen in the European Impressionist artists' creations and filling us with pride at finding our blue in those Western masterpieces.

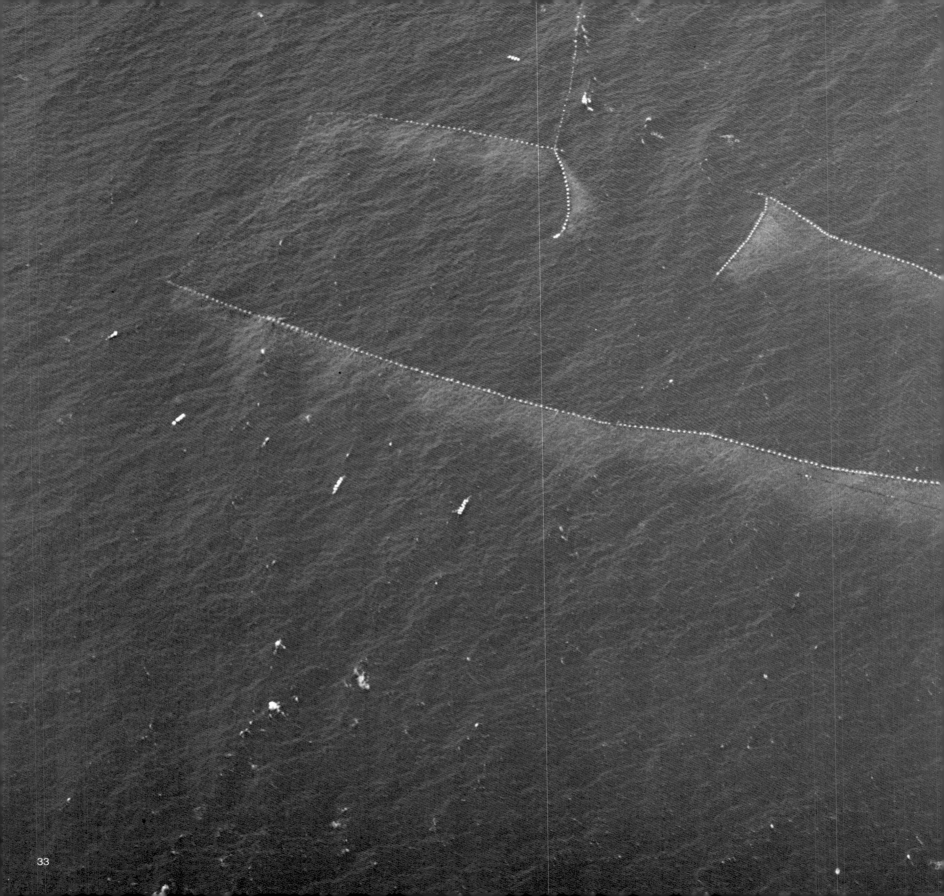

33

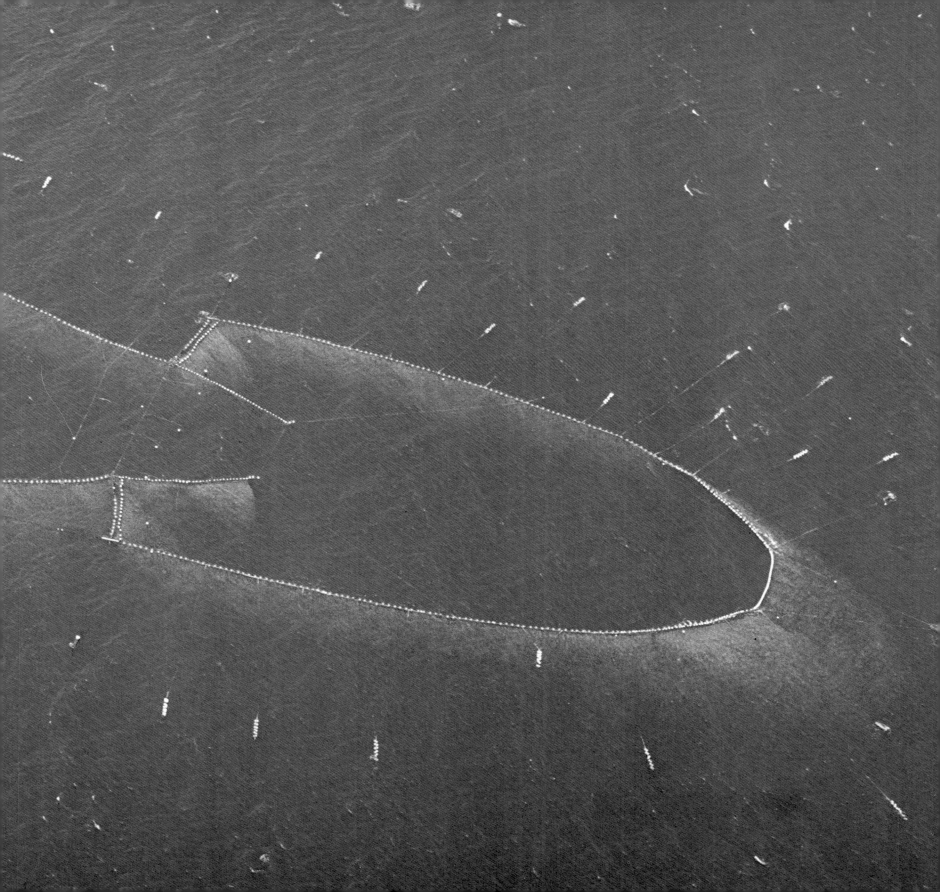

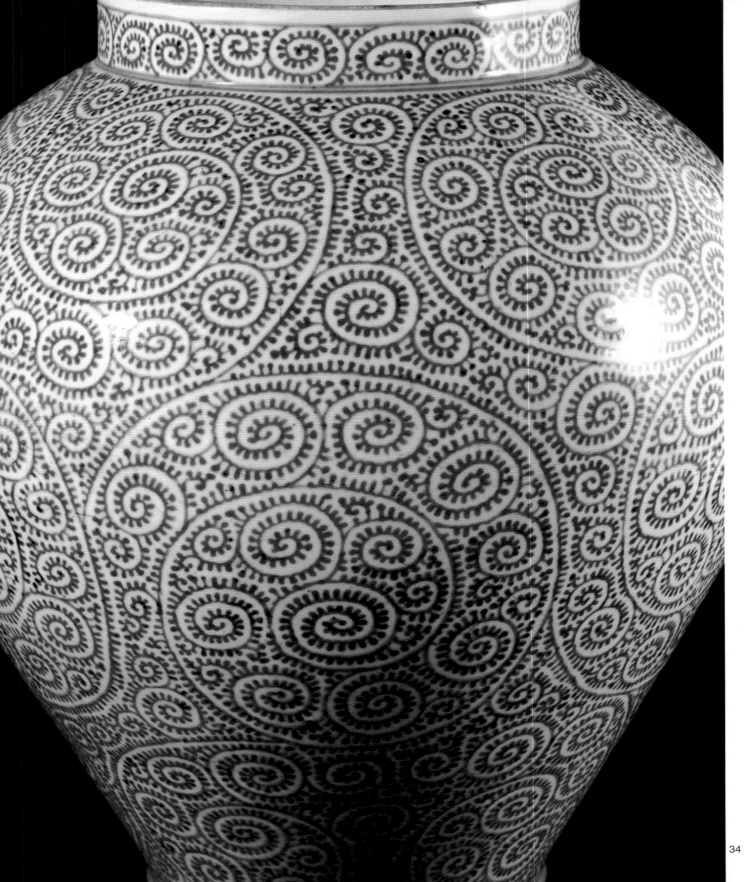

34

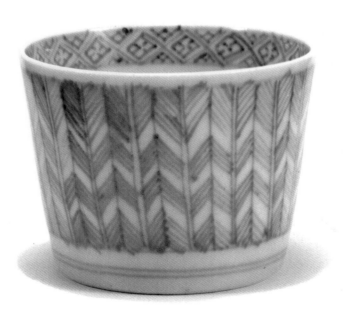

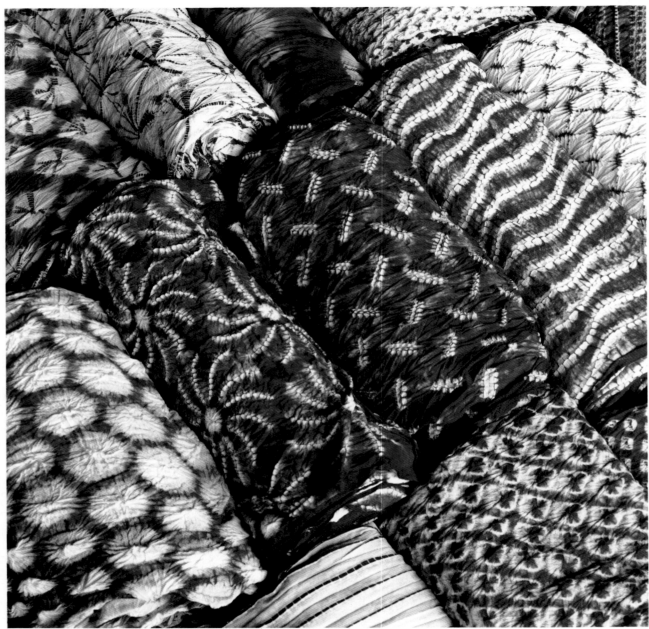

36

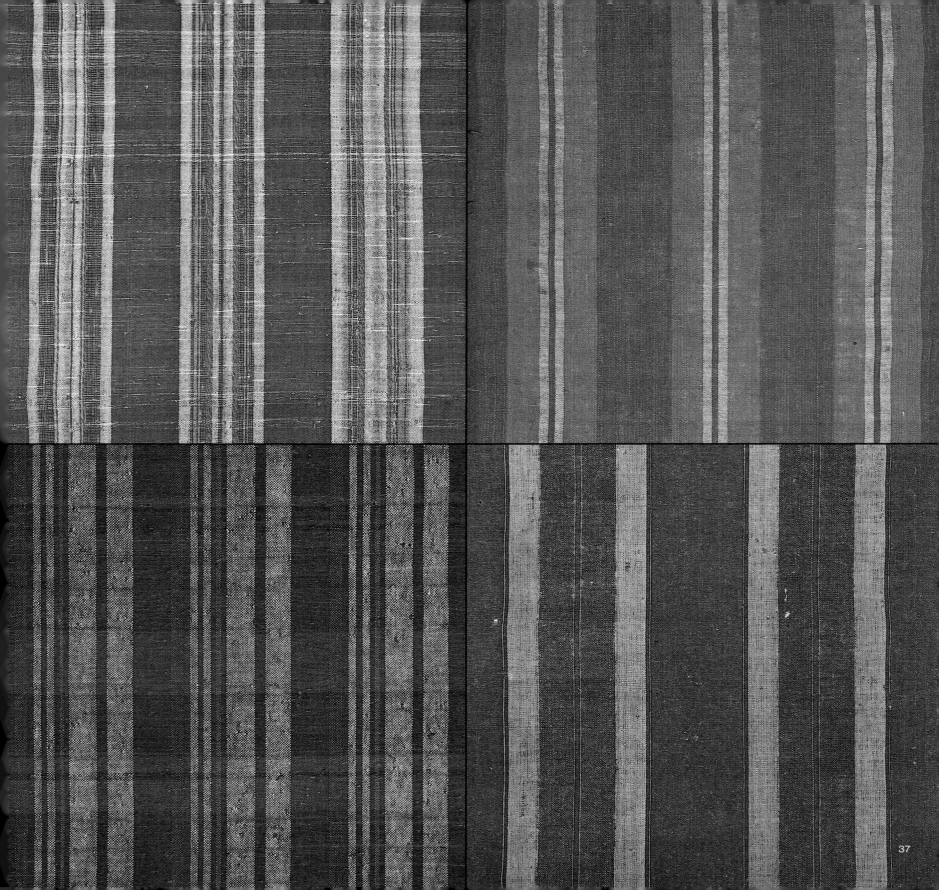

37

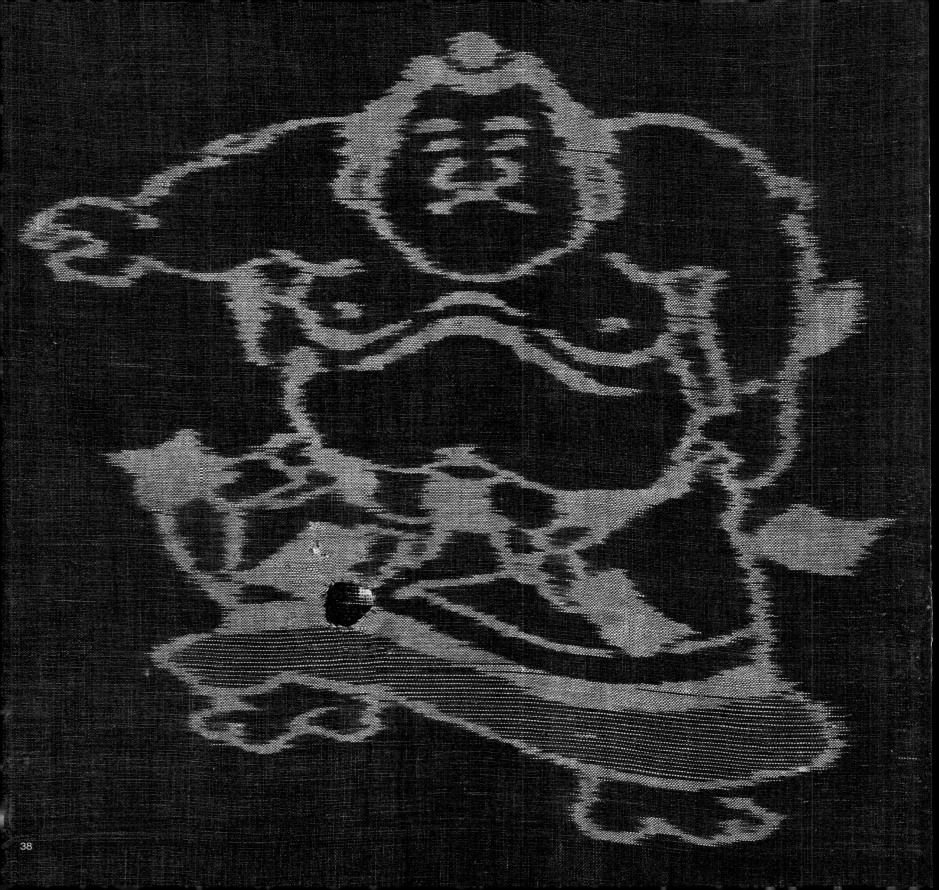

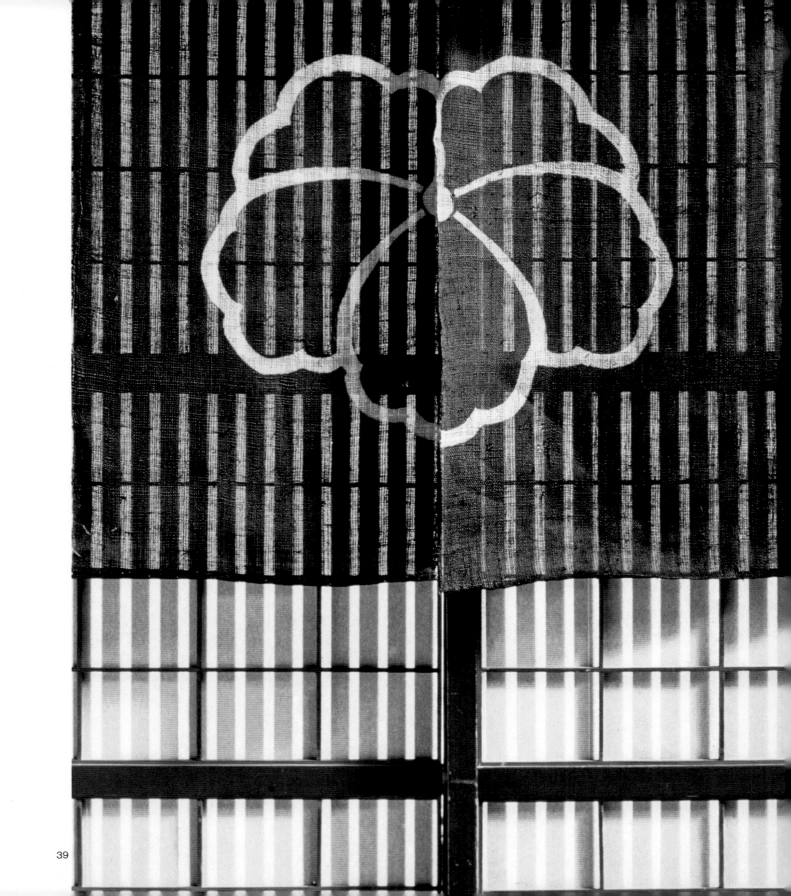

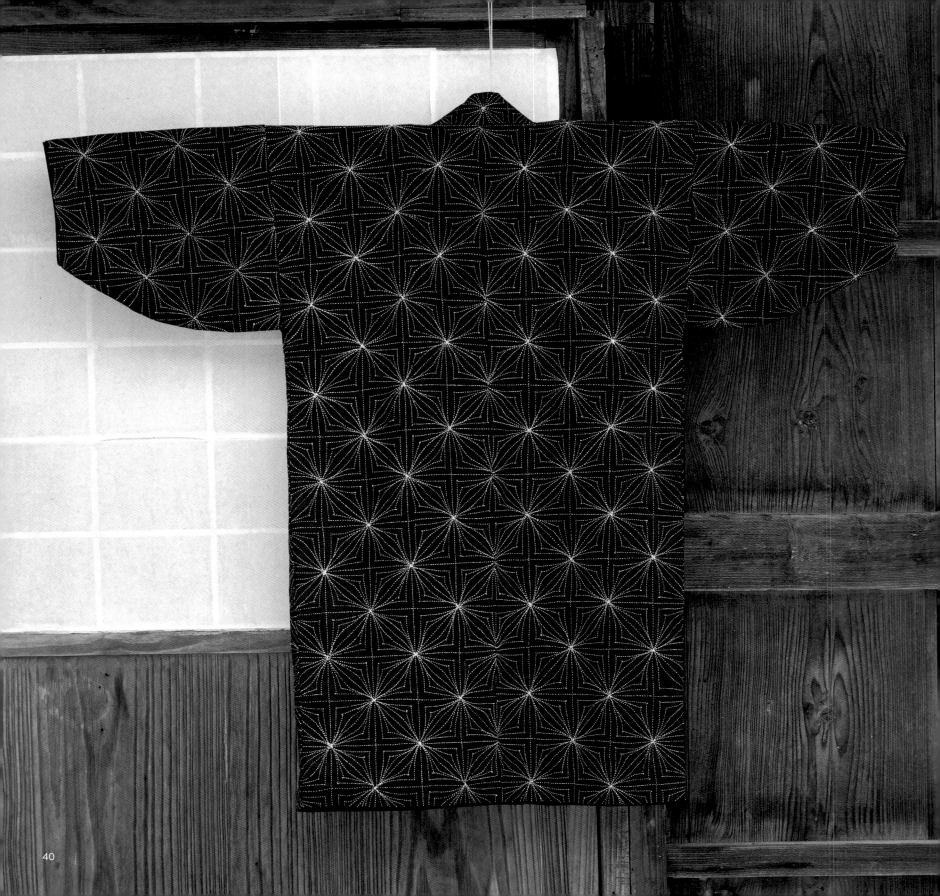

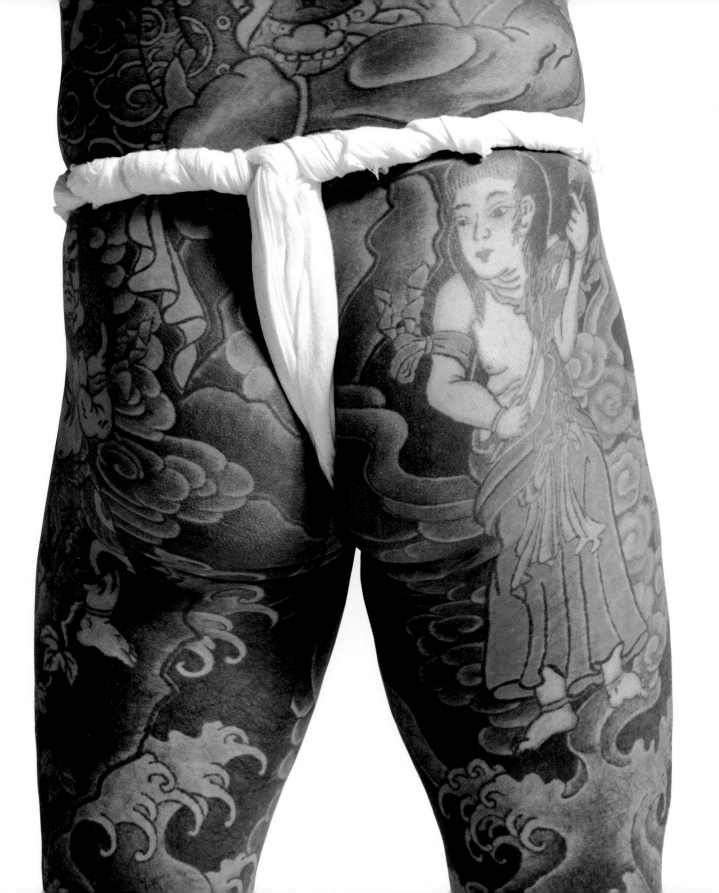

42

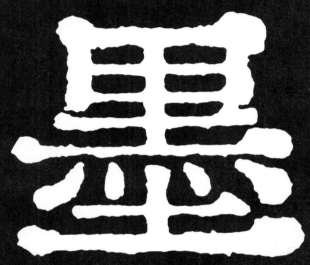

Sumi: Black —— the color of mystery; the color of the night. Night, a time when mystery, somehow differently from daylight, rules the world. Black expresses these depths of the unknown, encouraging the imagination of a different world from that of our daylight realities. It is the color of solemnity and at the same time can be found in every phase of our daily life, even including such areas as our foods like *nori* or seaweed for example. Japanese have long utilized this powerful color in the form of almost pure carbon, whose India ink has created the calligraphy, the drawings and paintings, wherein black letters and figures are dramatically expressed on white paper, revealing a mysterious existance in and of itself.

43

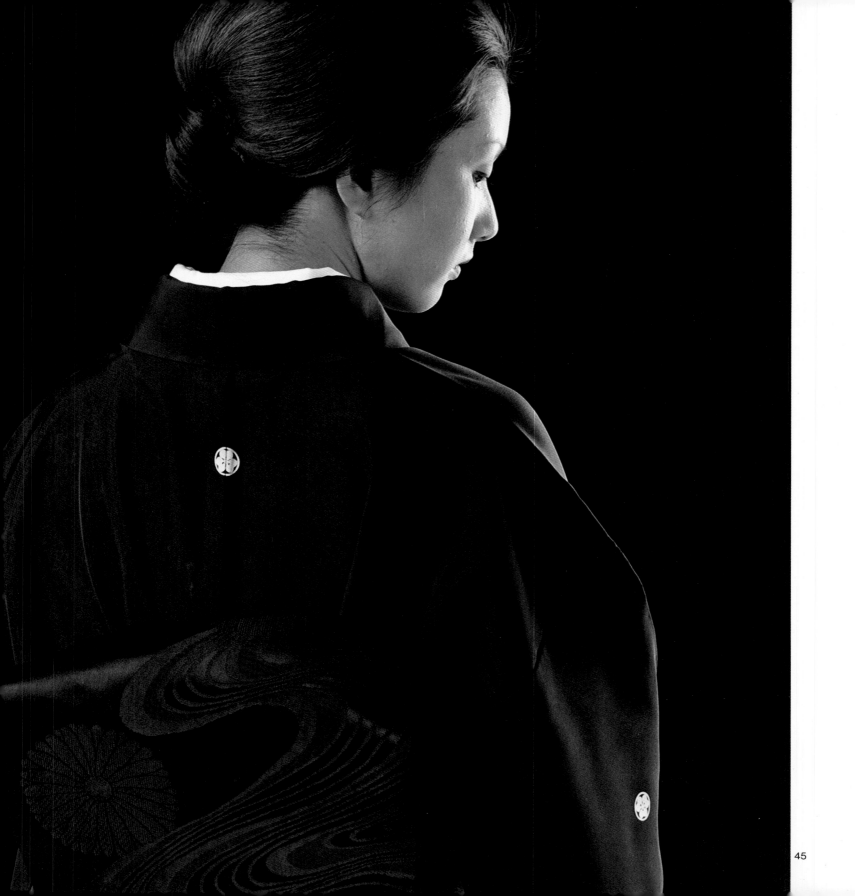

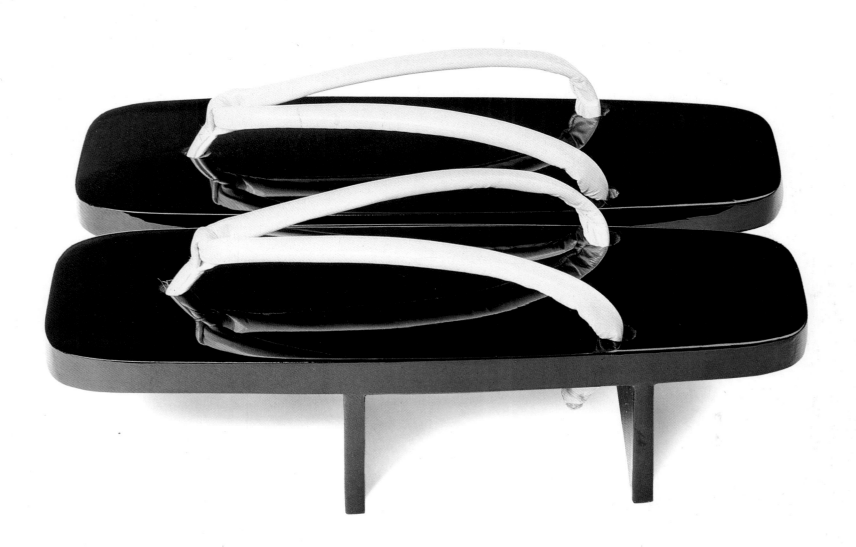

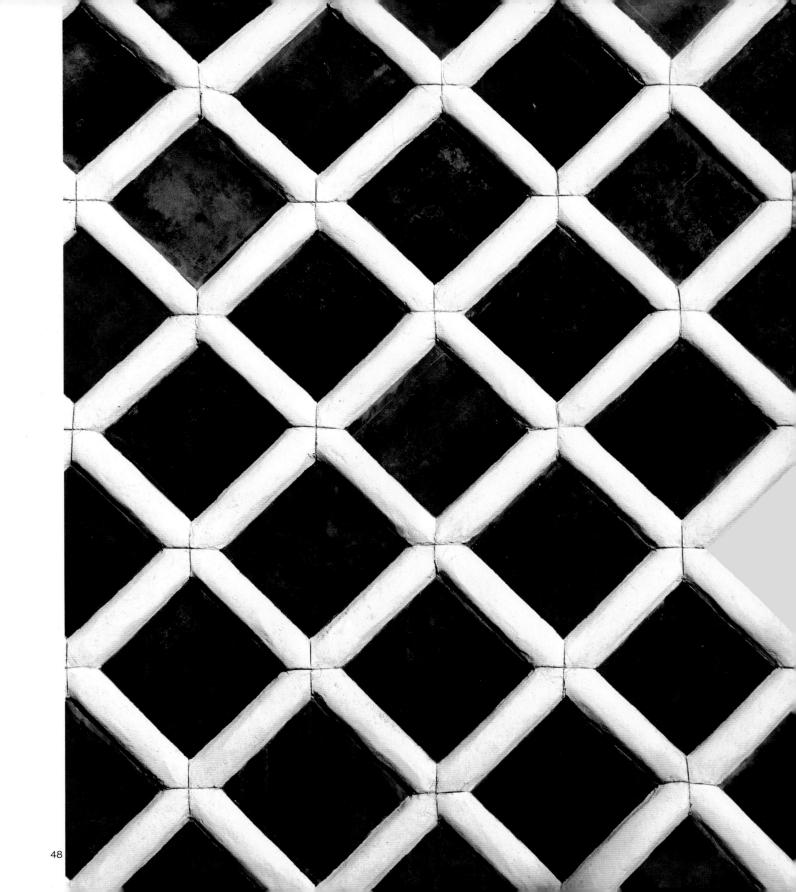

48

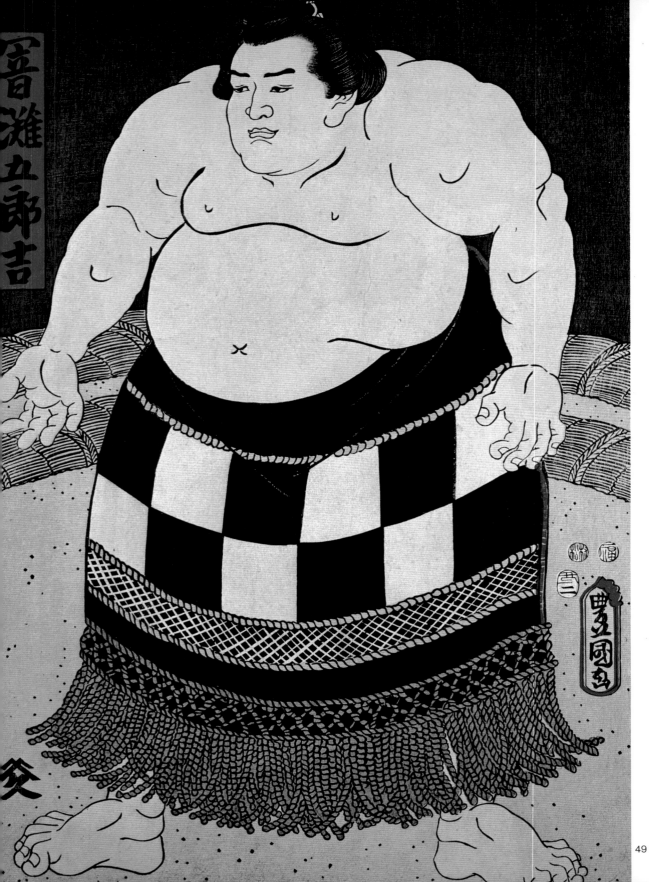

音灘五郎吉

炎

49

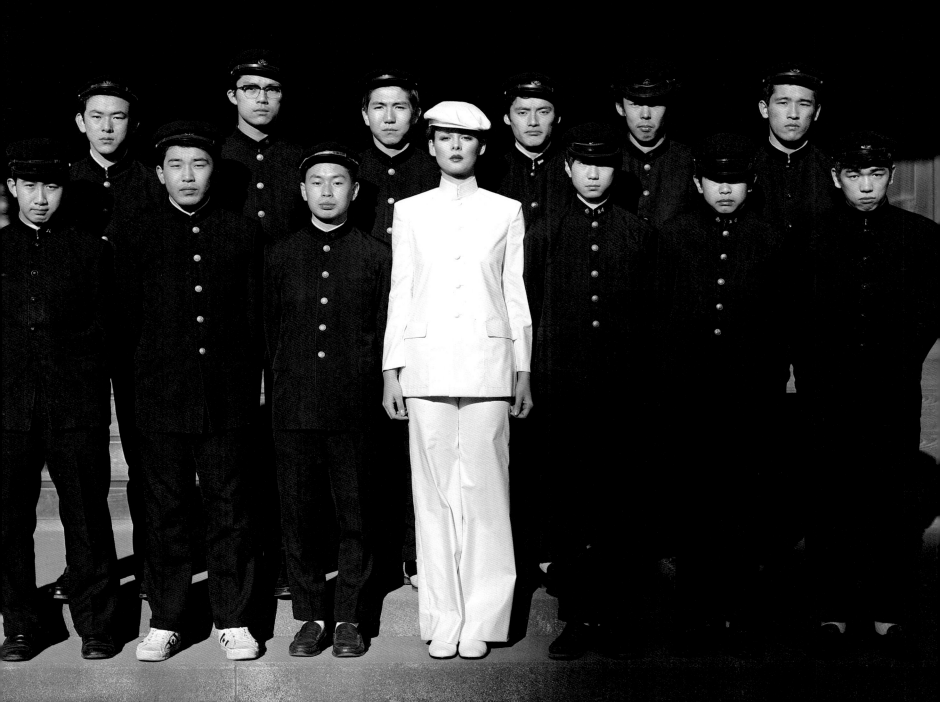

50

52

53

54

55

56

57

58

59

60

箱根園水族館

62

お楽しみはこれからだ

63

フィニッシュワーク展

64

クラベラ

65

すかいらーく

66

*Prosperous Harvest*————————

Kin: Gold ——— golden waves, *kogane no nami*, is an expression of our feeling, looking upon waving fields of ripened rice stalks. Harvested, these golden hulls are exchanged for hard gold currency. Interestingly enough, royalty in almost all cultures is synonymous with the glitter and enduring luster of gold. Royal personages have always worn the shining glory of god on their backs; it is the color of heaven, and is also thought of in that way in Japan. Statues of the Buddha, gold and shining against the glittering interior decorations of the temple, express this basic use of gold in religious installations, much the same as those to be found in Catholic churches. Those who have resided in the midst of golden luxury have often become our most powerful heroic characters.

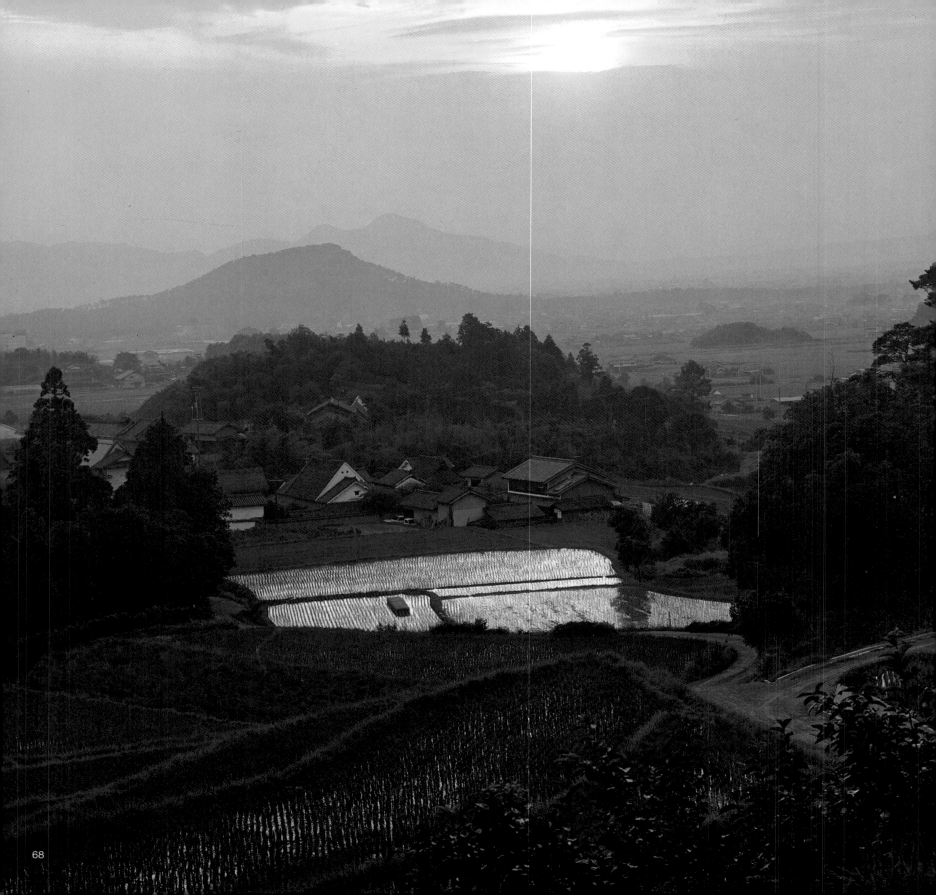

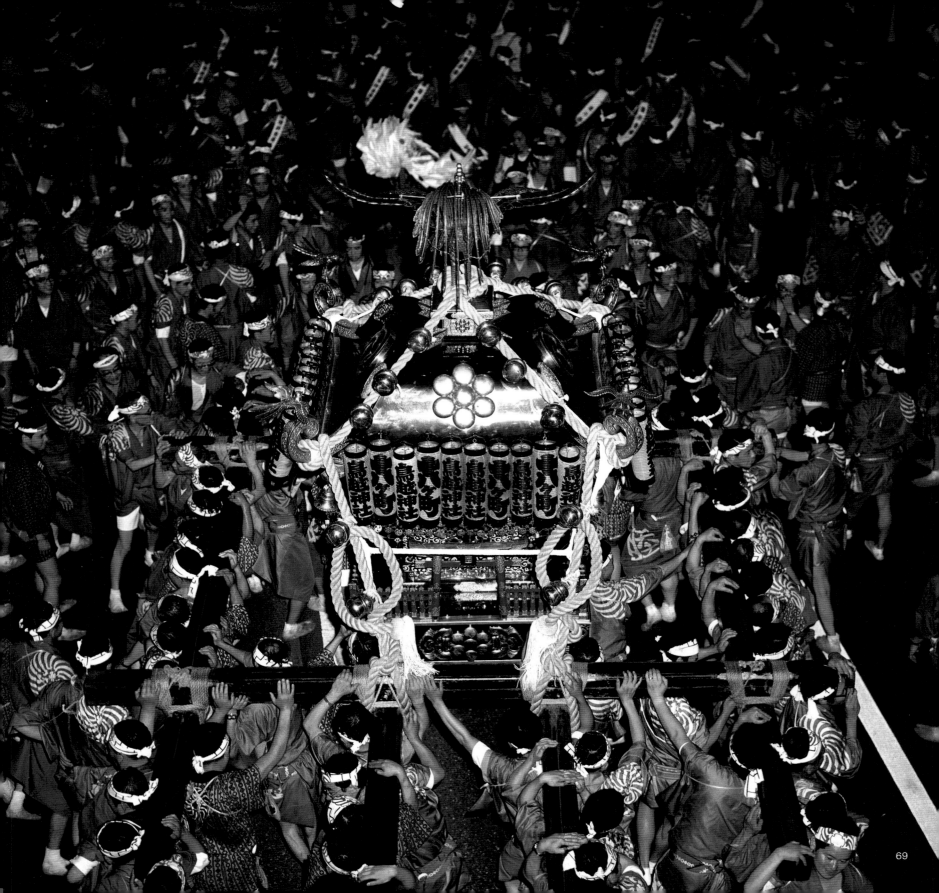

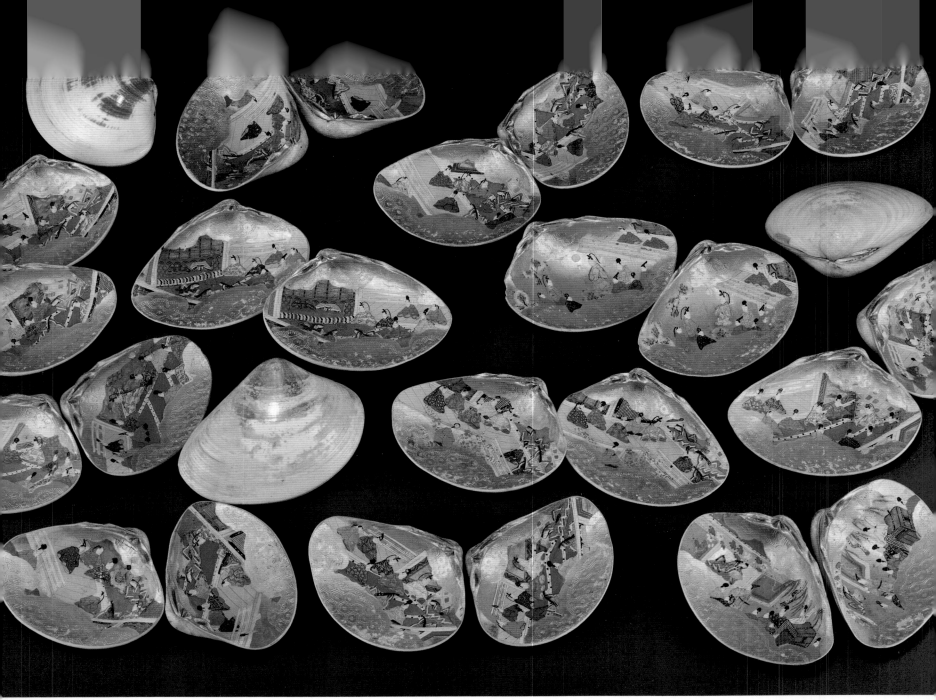

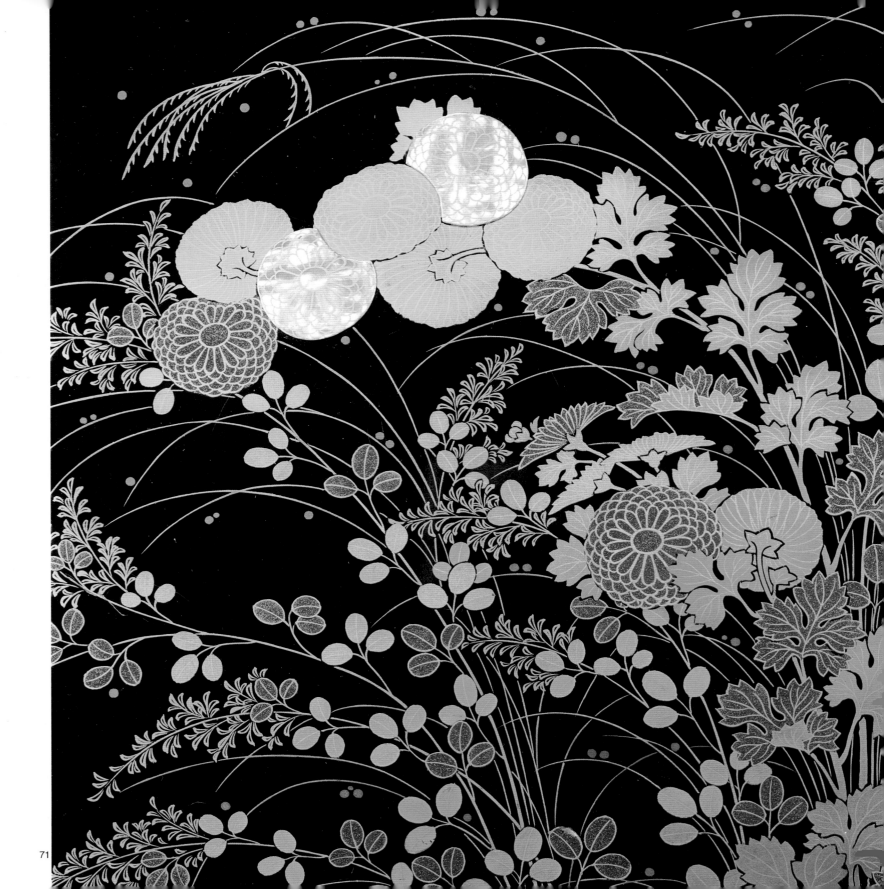

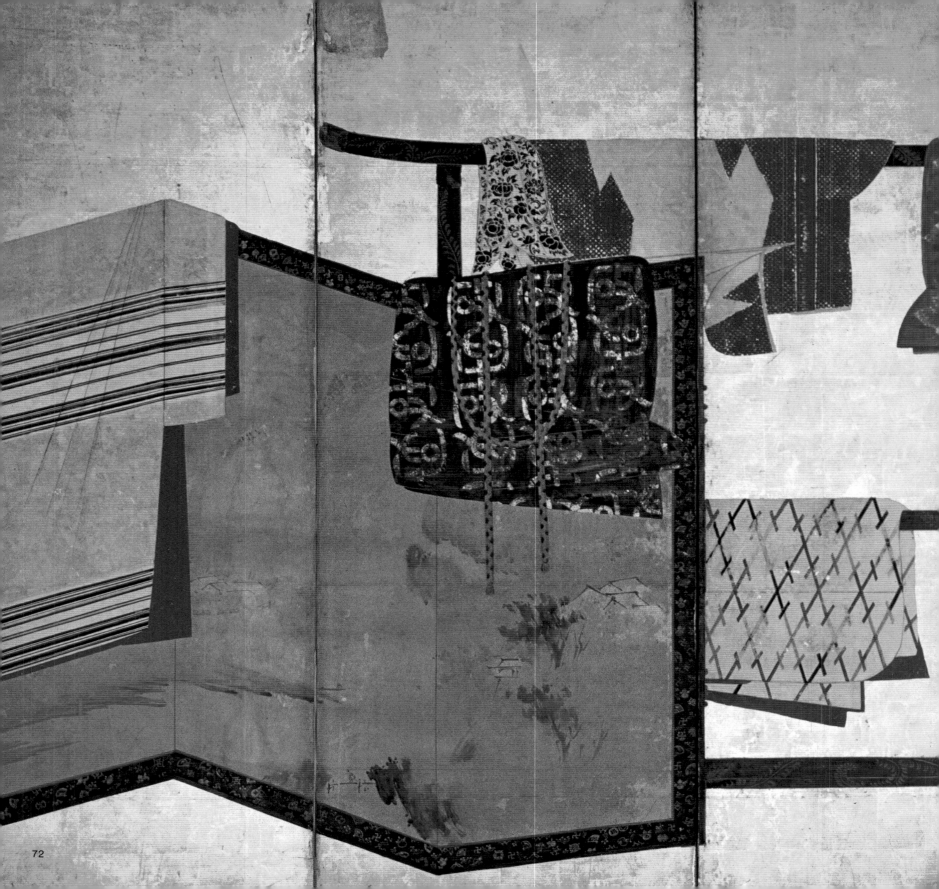

72

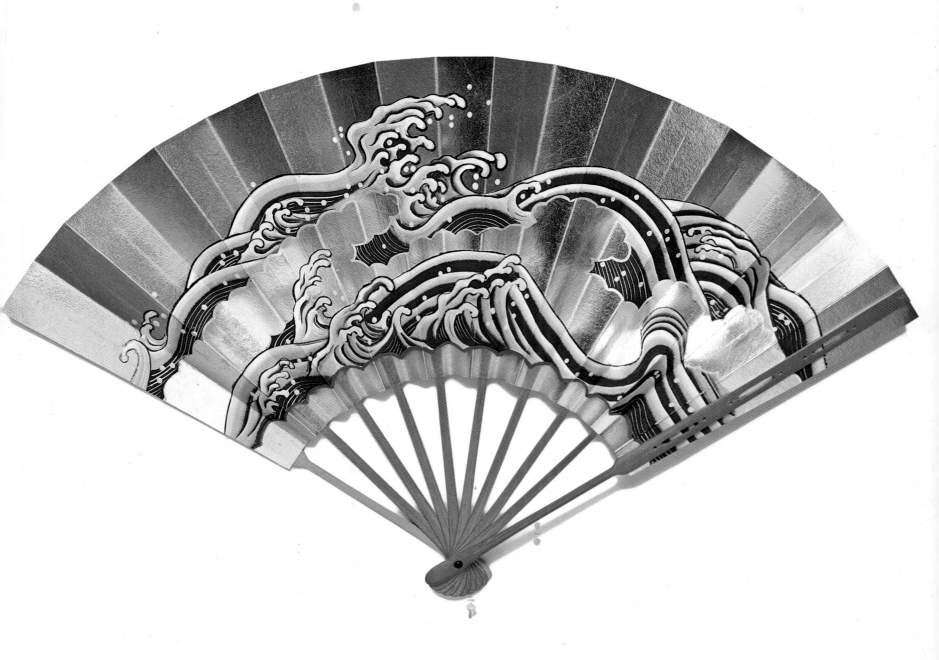

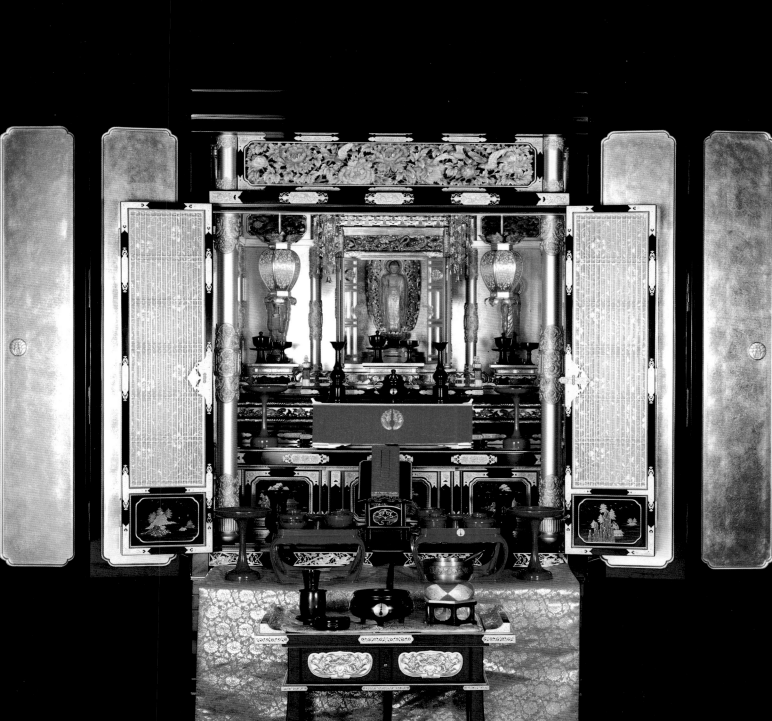

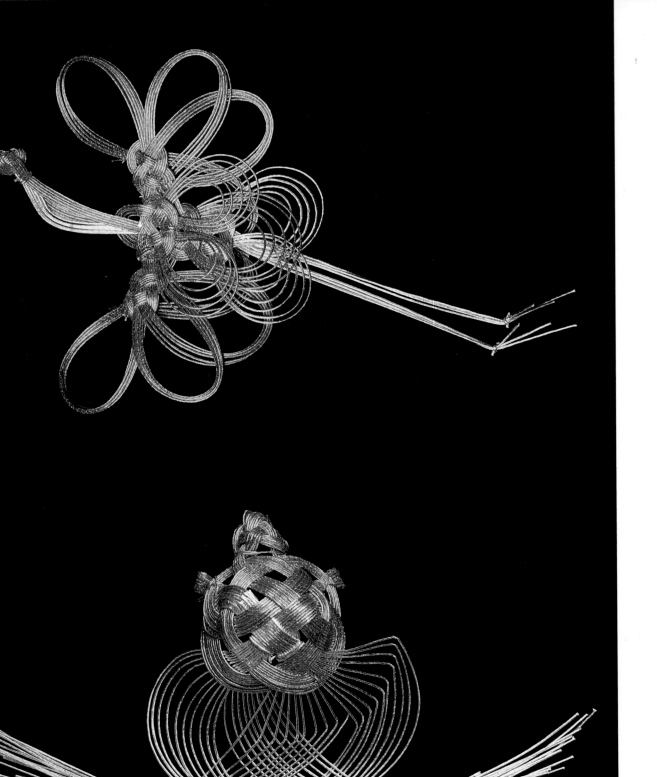

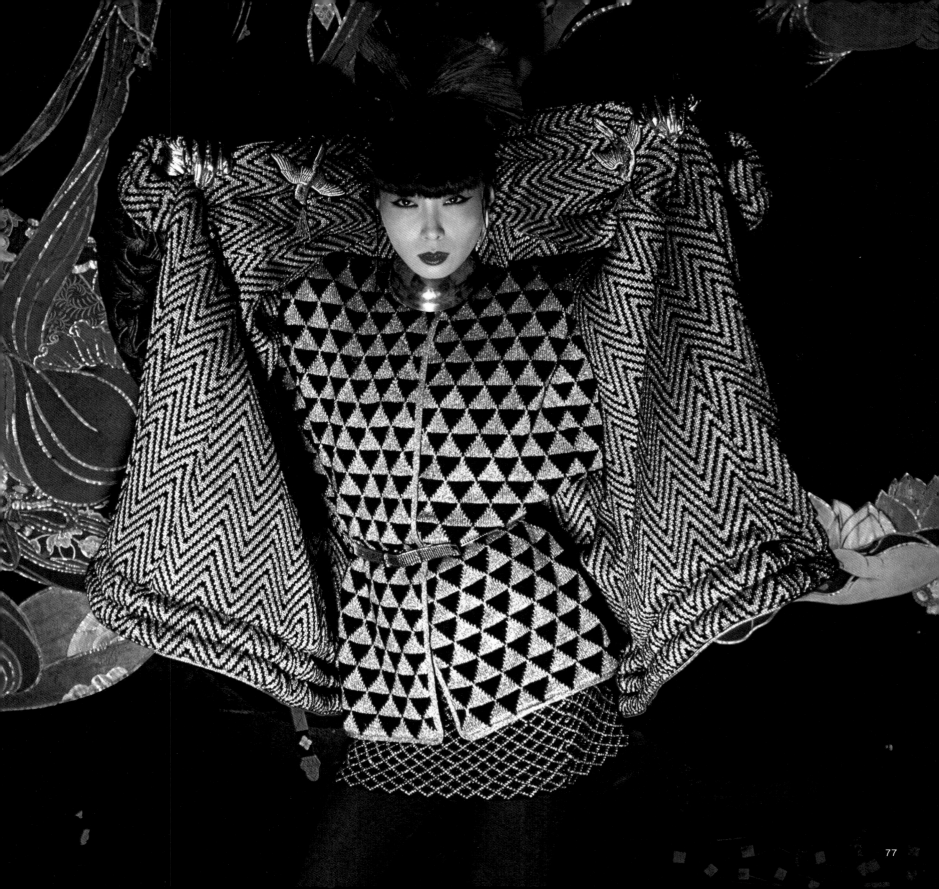

*Classical Performing Arts Friendship Mission of Japan*

Los Angeles  Washington, D.C.  New York

*UCLA Asian Performing Arts Institute 1981*

*Festive Expression* ———————

Tasai: Multi-colored ——— a multiplicity of colors: red and white, green, blue, gold, black, and many more. We can see that our traditional clothing, the kimono, as well as the sights within our villages, towns, and cities are full of incredibly rich colors. Our *matsuri* or festivals and other special occasions are treated to a feast of colors. When we contemplate staging a major contemporary event such as a world exposition, exhibition, or sports competition, our thoughts immediately tend to color the occasion to the full extent. Japanese coloring is, in normal daily life, generally monotonous. However, given the time and space of the extraordinary, everything becomes colorful. Colors, like those we have been investigating, exist all around us, symbols of Japanese life.

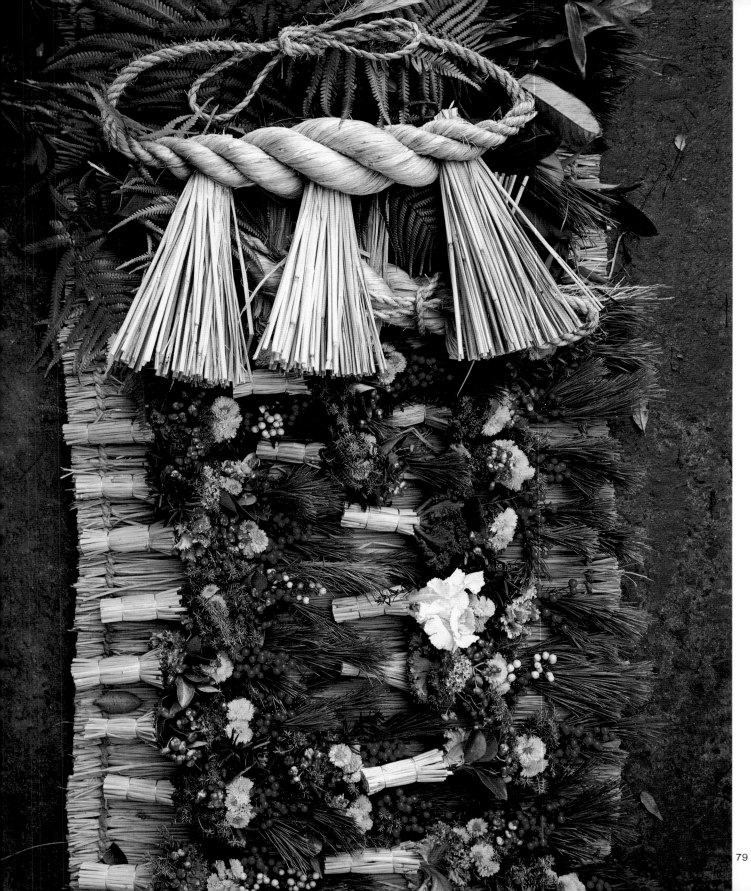

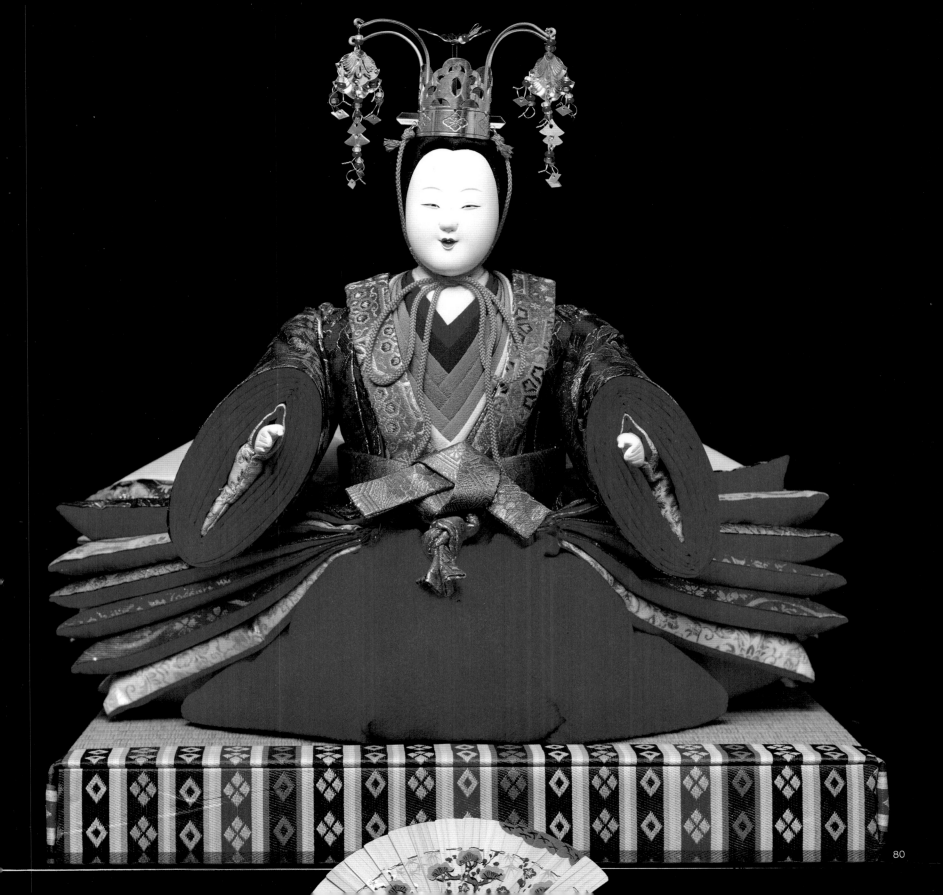

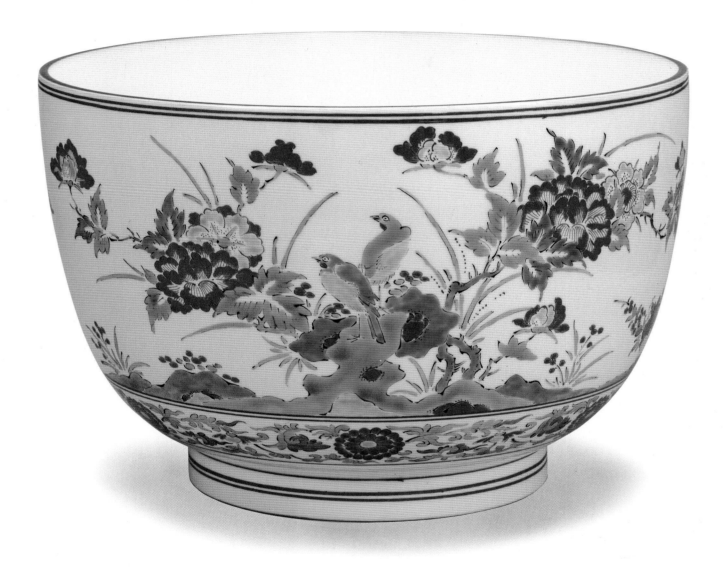

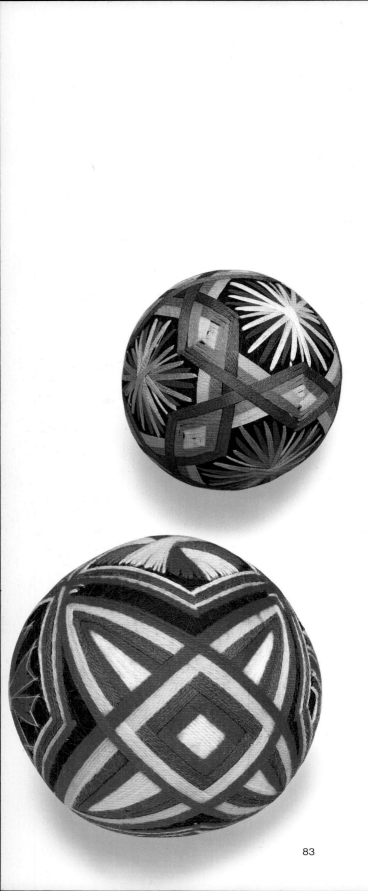

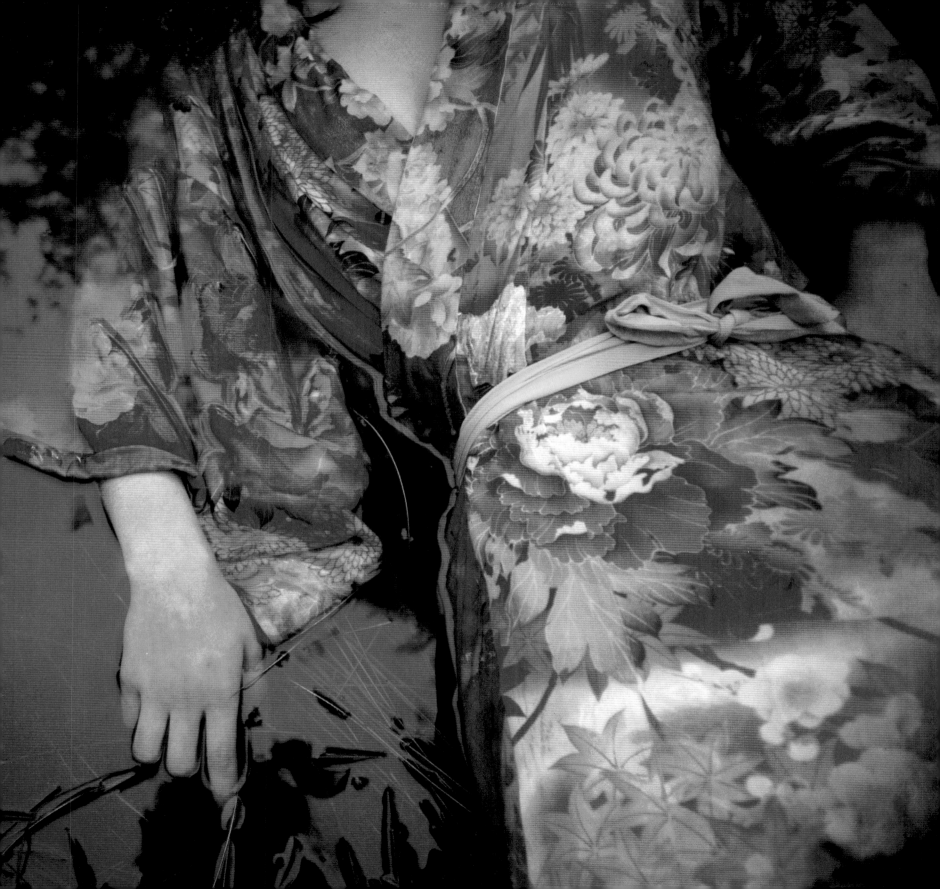

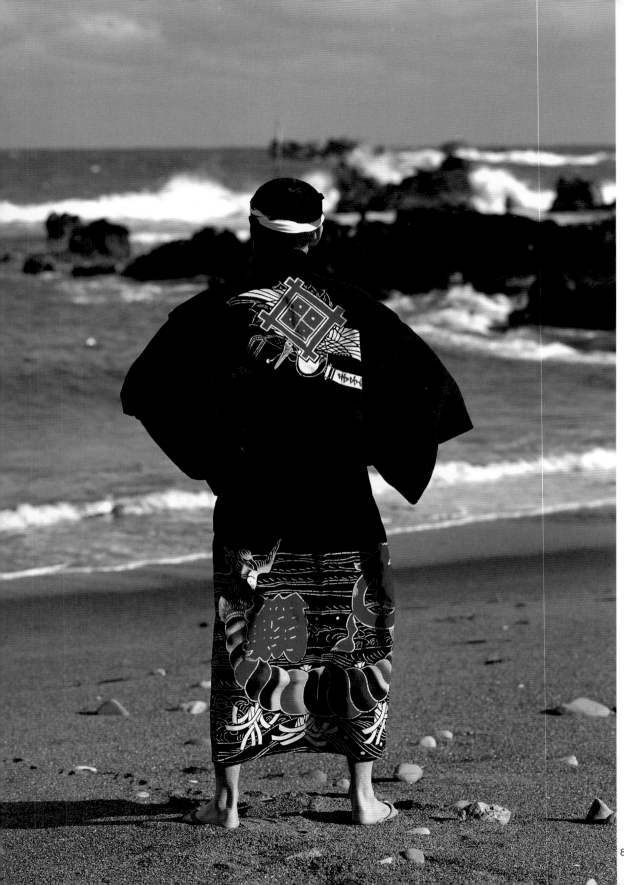

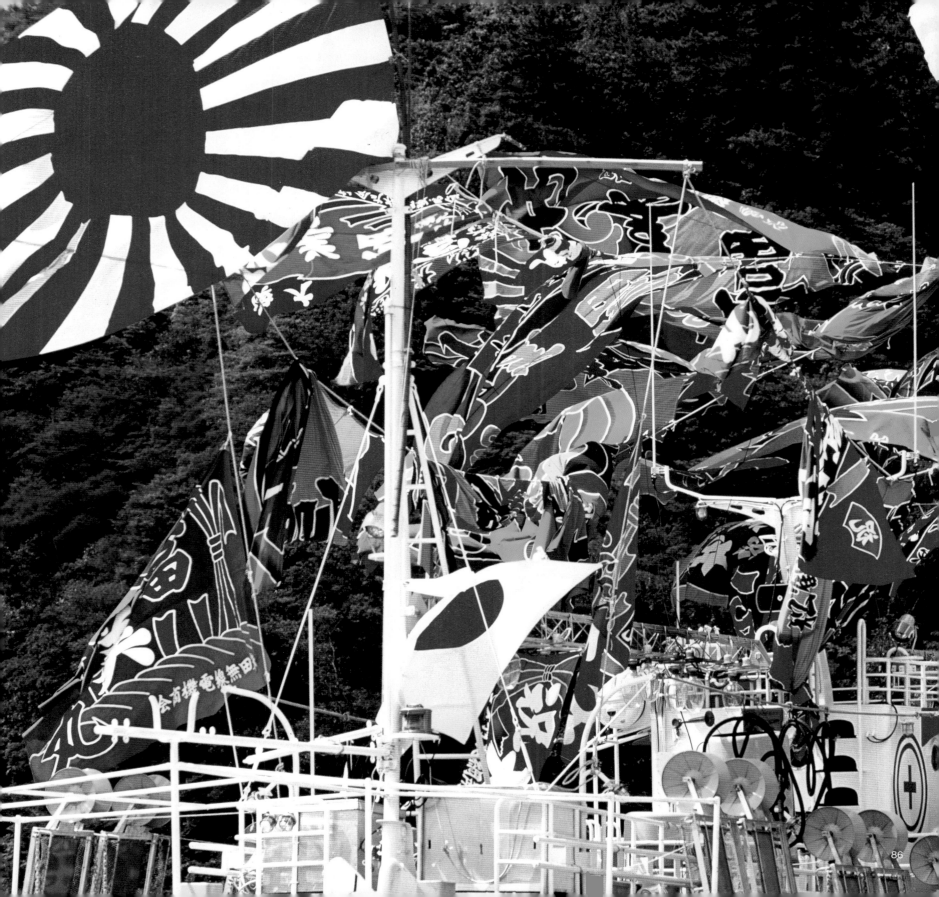

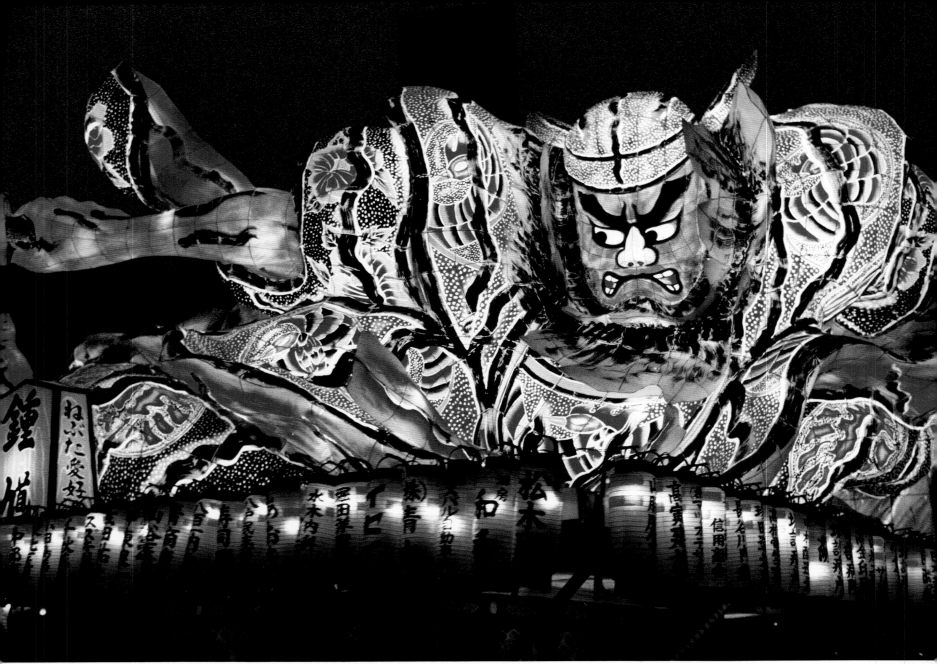

89

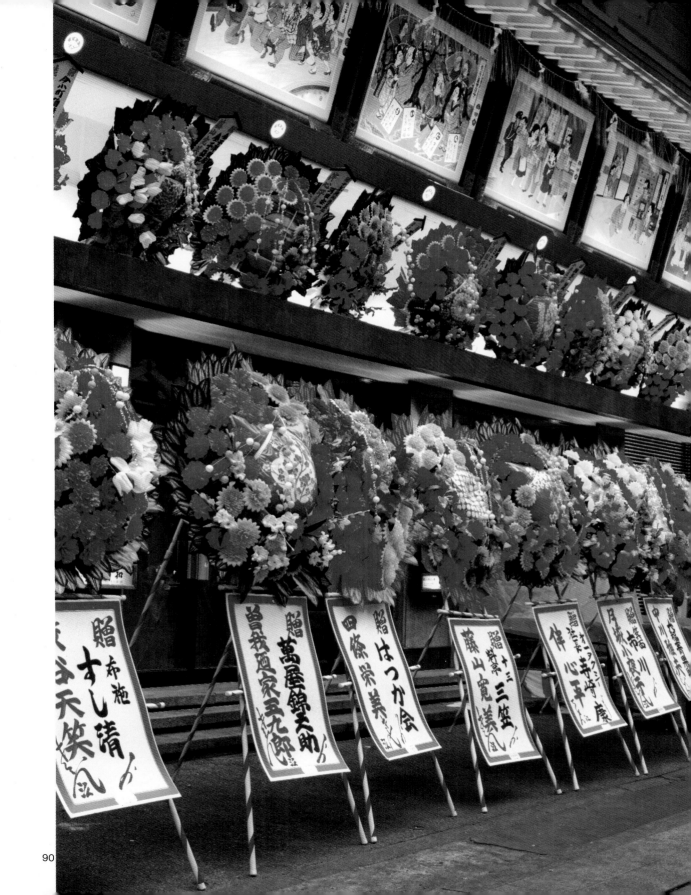

90

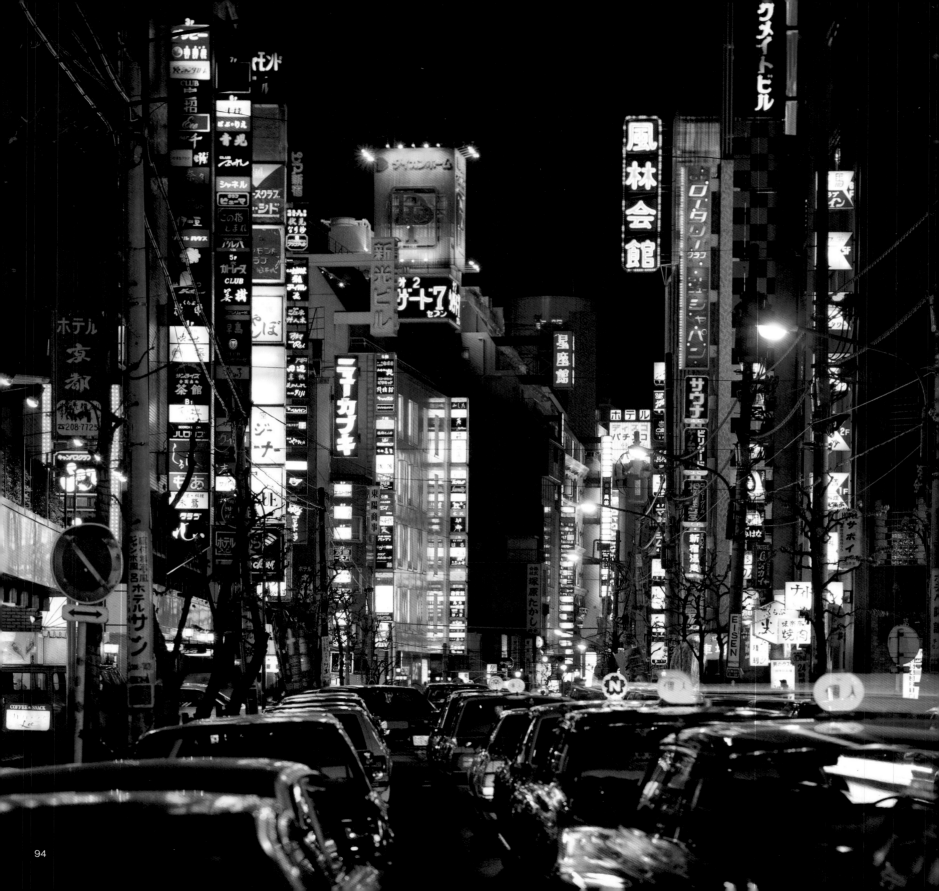

清らかな香りほど妖しい。 ⊛ 資生堂香水[禅]

9,000円

96

97

98

99

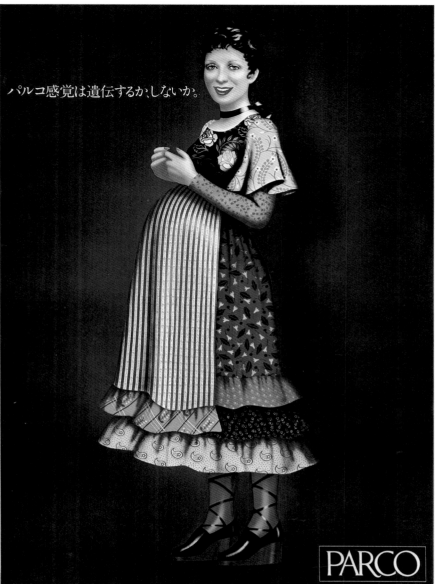

今夜も、ひと押しいたすかな。

104

音楽は磁性紀に入った。

FUJI
CASSETTE

105

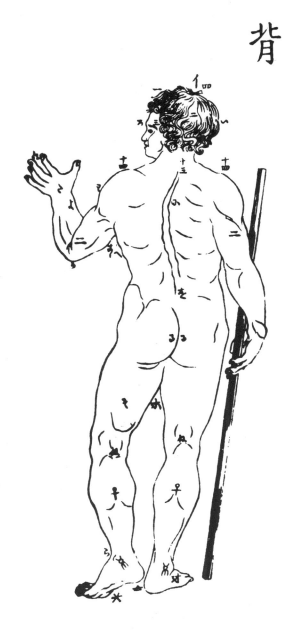

背

Illustration from "Ontleedkundige Tafelen", published in Japan as the first introduction of western medical science, 1774.

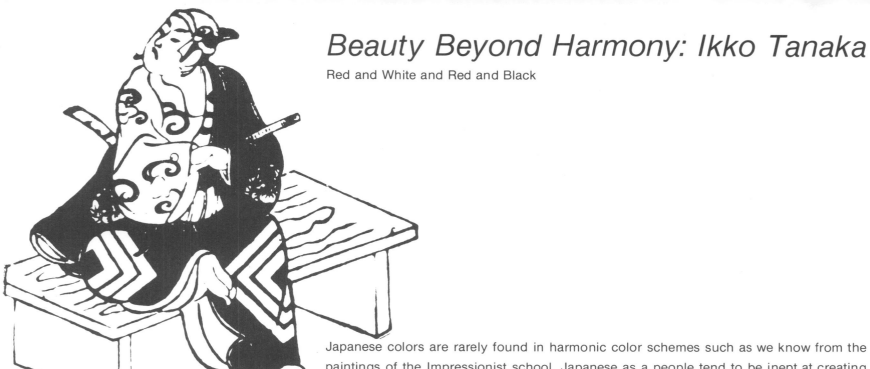

# Beauty Beyond Harmony: Ikko Tanaka

Red and White and Red and Black

Japanese colors are rarely found in harmonic color schemes such as we know from the paintings of the Impressionist school. Japanese as a people tend to be inept at creating things by the adding together of separate or discrete units. Their more typical approach is rather to garner and concentrate strength, and then to execute something all at once, in a momentary act. Indeed, Japanese seem to have an inherent affinity for the extemporaneous, as illustrated in the arts of calligraphy and in *suiboku* painting in which every brush stroke is final and irredeemable, and in *shakuhachi* (vertical bamboo flute) and *tsuzumi* (hand drum) music with its pauses and explosive progressions that defy analytic appreciation.

Colors in Japan, furthermore, while on the one hand gentle and unprepossessing, are also quite straightforward. Japanese, in contrast with Westerners, grasp colors on an intuitively horizontal plane, and pay little heed to the influences of light. Colors whether intense or soft, are identified not so much on the basis of reflected light or shadow, but in terms of the meaning or feeling associated with them. The adjectives used to describe colors, like *iki* (sophisticated or chic), *shibui* (subdued or restrained), or *hannari* (gay or mirthful), tend to be those that stress feelings rather than the values of colors vis-à-vis one another. Thus colors are placed together in a straightforward, contrastive way, bringing out the qualities of each. One finds in Japanese culture from ancient times combinations of conflicting colors— red and green in the temples of the Nara period and in Shinto shrines, scarlet and black in medieval armor, gold and green in screen paintings of the Azuchi-Momoyama period, red and white for accessories for auspicious occasions, and the dark blue and white of *yukata* and *kasuri* fabric. These are combinations that mingle religious faith, human sentiment, design and materials, and give form to Japan's distinctive colors.

The same is true with the pink and white used in Japanese rice cakes and the black and white of the diagonally tiled walls of store-houses known as *namako kabe*. Kabuki costumes, too, display many striking contrastive color combinations of two or three colors—red and black,

purple and red, red and green, or purple and yellow. The jumbo cheque pattern in purple on a white ground of the costumes of Umeōmaru and Sakuramaru in *Sugawara Denju Tenarai Kagami* (The Secrets of Calligraphy), the yellow *tabi* of the comic character Bannai in *Chūshingura* (The Treasury of Loyal Retainers), the green and brown of Asahina's garb in *Shibaraku* (Just a Moment!)—all are color combinations startlingly modern in conception. In Western opera and ballet, the colorful costuming of groups of actors on the stage and the use of lighting are impressive. Even in the same theater arts, Japanese somehow seem unable to achieve the same subtle harmonies of color. On a deep stage, for example, the positioning of performers in orange downstage, in pink to stage left, and in violet upstage, creates a special beauty of three-dimensional light. Such an effect, like the colors of a stained glass window reflecting on the floor of a dim cathedral, possesses a wholeness that has density and depth. Tradition, ultimately, is the determining force. Some say that the Japanese kimono is the showcase of two-dimensional, pictorial designs, while the Western dress is modeled to set off the sculptural, three-dimensional qualities of the human body. This is a contrast that may well carry over to the culture of colors in the West and Japan.

The Western conception of color is fundamentally related to that which is physical. Even before the discovery of the principles of the spectrum and the prism, Western colors appear to have been intuitively thought of in terms of their physical values. This may have something to do with the climate in the West where the air is dry and clear and high value is attached to precious jewels that reflect the light. The portrayal of light, for example, in the paintings of the late Impressionist Seurat, can only be found in the West. There, the canvas is covered with innumerable dots of color, which together create a picture of subtle color nuances, like a mosaic or Gobelin tapestry. A Western arrangement of flowers is perhaps an even better case in point. Invariably it displays a complex orchestration of colors as fixed element— pink, orange, yellow and violet, and, like the musical score that indicates the harmony of bass, baritone and tenor voices, there seems to be some system of aesthetic rules for colors as well.

In Japan, on the other hand, such rules hardly seem to apply, for the value of colors is determined by their context. Red is one color that is extremely unstable in value. While susceptible to a reputation of ostentation and vulgarity, it can also be a color of unexpected beauty. At the same time, if caught in the spell of red's beauty, one can be overwhelmed by its unbearable rawness and sensuality. Colors like blue and yellow may easily be assigned fixed values, but red is radically altered by the color company it keeps. Red and white create a whole different world, for example, from that of red and blue. This may seem obvious since white is an achromatic color and blue is nearly complementary to red. But red possesses a dimension that cannot be gauged in terms of the aesthetic effect of chromatic color combinations alone. It is perhaps the color most rich in the associations of the climate and culture where it is used.

Red is the color of fire and of blood, and thus it is the most sensual and physiological. It is associated with man's most profound urges and impulses. More over, throughout the history

of the ancient Orient, India, China and Japan, red has been a traditional color of magic and sorcery. It is for man the symbol of life.

Red is perhaps at its most beautiful when juxtaposed with white or black. These combinations seem to transform red instantaneously into a color typically Japanese, and it is a color especially associated with the *fin de siècle*-like cultural ferment that took place during Japan's long period of isolation in the Edo period (1603—1868). White, meanwhile, has been prized since antiquity as the color of purity, innocence and virginity. The *gohei*, a sacred white paper ornament used to signal the boundary of a sanctified territory in the Shinto religion, is an example of its associations. But when this pure white paper is combined with red, it is instantly transported to the realm of the mundane and the human. Here, white functions as *yang* and red as *yin*. The combination of red and white in the decorative ornaments used on wedding or engagement presents—*noshi* or *kaishi*—has a compelling quality that suggests man's urge to create a bond between his own life and the gods.

The red and white color scheme somehow seems particularly typical of Japan, but this is not only because the Japanese flag consists of a red sun on a white ground. In fact, there is a virtual cult of *ko* and *haku*, red and white, that has been firmly established in Japan from ancient times. Ancient buildings were constructed in plain, unfinished wood and painted with red lacquer. The banners of the Genji and Taira clans who battled over sovereignty of Japan in the ancient period were red and white respectively. Court ladies and shrine maidens in ancient times wore red pantaloons with white overkimono. In traditional Kabuki lion dances, the costumes are completed with massive red or white wigs with long manes. On festive or happy occasions, curtains with broad red and white stripes are hung up as a backdrop and pink and white colored rice cakes and other sweets are served.

Red is a color that wards off evil, and is a color that can hold its own with equal strength against white. The chromatic concept of red and white takes classic form in the make-up techniques used in *aragoto*-style Kabuki performance, as devised by the leading seventeenth century actor Ichikawa Danjurō I. The powerful, dynamic highlighting of features and vein lines in deep red (*beni*) over white powdered face and skin clearly illustrates the Japanese fascination with the black arts in which red symbolizes human life.

In contrast to white, black is the color of the lightless night, and of death and all that man abhors. In East and West alike, black is an unlucky color, but in Japan, when combined with red, it is completely transformed. These two colors exude an irresistable sexuality in combination, and here red takes the role of *yang* while black serves as *yin*. The eroticism of these two colors is demonstrated in the scarlet threaded armor of young warriors of medieval times, in the jackets of the valiant firefighters of premodern Edo and even in the colors of Daruma dolls, toys and flower cards. It also appears in the linings of the black silk crepe dress kimono worn by geisha or the red inner trimming of black silk kimono. Against mourning black, red introduces the element of humanity and life, like something aflame.

The Kabuki plays and dances that developed in the mid-Edo period provide many examples of this: the gesture in which an actor removes one arm from the sleeve of a black formal

kimono with family crest revealing a plain red underkimono beneath is well-known in the swagger of Sukeroku and in the posturing of Kampei of the journey scene in *Chūshingura*. It is also exemplified by the red gators of Gompachi in *Suzugamori*, and in Benten Kozo's female disguise. Especially in the journey scenes of Chikamatsu's love suicide plays do we find the eroticism of death suggested to dramatic effect in fleeting glimpses or red at the sleeves and hems of the characters' formal kimonos. These brief flashes of bright color make all the more moving their sorrowful fate. Blue and yellow do not express this feeling; it is the mysterious fascination of red alone.

Red and green are a striking combination too, but there is something in these two colors together that seems to belong to continental culture. Red and blue is a totally Western combination. One senses that these are imported pairings of colors, not indigenous to Japan. Red alone seems to evoke conflicting images in East and West.

The red found in the Parisian café terraces is unlike our Japanese *hi* (bright red) or even *beni* (deep red). It is scarlet or perhaps carmine. The red of the stained glass windows of Western cathedrals is shot with a shade of blue. These hues, as well as the red that shines through a glass of burgundy and the deep richness of a rose are colors fundamentally far removed from that of the carpet one may find spread in a Japanese garden.

Among other colors, most are abstractions from nature—colors like *yamabuki*, the yellow of the Japanese rose, *fuji-iro*, wisteria purple, *moegi-iro*, the light green of sprouting onions, *uguisu-iro*, the yellow green of the plumage of the Japanese nightingale, *tobi-iro*, the light brown of the *tobi* or black-eared kite, and *momo-iro*, the pink of the peach blossom. All these are somehow self-explanatory, unlike red, which seems to resound from the deepest recesses of the human soul.                              (translation by Lynne E. Riggs)

# Shades of Feeling

*Kazuko Koike*

**Front and back covers:**
Photographer Taishi Hirokawa has captured the contrasts which constitute the Japanese in his front and back cover photographs. On the cover we see the symbol of the Japanese in the same way that chicken soup with barley reflects the Jewish mother's specialty or cafe au lait with croissant for the French. For us it is a small plum fruit which has been dipped in red *shiso* (a spicy herb) and pickling salt to produce a sour plum called *umeboshi*, dried plum. Delicious with steamed white rice, it is placed on top in the center of the *bento*, box lunch, and looks exactly like the Japanese flag's *hi-no-maru* sunrise. While wives and mothers still prepare *okazu*, a variety of tasty side dishes to go with the hi-no-maru bento, surveys show that currently fewer and fewer children eat rice, preferring bread with their meals. The back cover contrasts with the red and white of hi-no-maru: *nori-bento* or *nori-ben*, a slang expression for a box lunch of rice covered with black eatible seaweed. While the eating of black seaweed is very rare in western countries, we feel that dried black seaweed, black sesame, and black (brown) sugar are all good for your health. Seaweed is delicious with *shoyu*, soy sauce.

## Red and White

### #1 Gohei: sacred white ornament
As a very small child I used to wonder why this particular paper ornament could so strongly restrict a certain area from our free-ranging territory of fun and games. Now, of course, it seems obvious; this cut and folded hanging tassel of pure white *washi* (Japanese paper) is what we call a *gohei*, an ornament signifying purification in the indigenous Japanese religion, *Shinto*. *Kami*, or gods, can be found in all natural objects and phenomena. Another sacred absolute in the observance of this faith is the *sakaki* tree which signifies purity with its leaves displayed on an altar or around a space, indicating to everyone that the ground hàs been purified and that the gods now reign supreme over the area.
photo: Takeji Iwamiya

### #2 Noshi: gift envelope
These decorative envelopes are part of the very traditional presentation at the time of a marriage engagement. On this festive, auspicious occasion, the use of red and white *noshi* are particularly appropriate. While this type of formal gift envelope is not often utilized in our contemporary life, small, simplified noshi can quite often be seen printed on wrapping paper for gifts. The word "noshi" takes its meaning from the ancient practice of wrapping a piece of stretched (*noshi*) and dried abalone shellfish inside white paper as a polite and courteous offering of friendship.
photo: Takeji Iwamiya

### #3 Danmaku: curtain fence
Bright cotton curtains of red and white are an incredibly useful traditional means of taking an environmental space and turning it into a festive locale full of celebratory atmosphere. Called *manmaku*, it's used for new building dedications, around new car showrooms, announcing the local shrine's autumn festival, or at the school yard for the annual athletic meet. In the kabuki theatre's famous dance drama, "Dōjōji," the *danmaku* curtain is powerfully used as the backdrop for the temple yard dedication of a new, large bell (attached to the long red and white cloth covered rope). Here, the famous *onnagata* (female role) actor Baiko Onoue charms the temple apprentices before entering through the prop gate.
photo: Kakichi Hayashi

### #4 Keshō: make-up
Tamasaburō Bandō, the most successful young onnagata kabuki actor in Japan today, poses here to show the *butai-geshō* or stylized stage make-up for a young princess, *akahime*, role. This type of make-up is also used by dancers of *buyo*, traditional Japanese dance, and by *maiko*, young apprentice *geisha*, female entertainers. Many layers of *oshiroi*, white powder, are applied to the face, neck, arms and hands. *Beni*, the rouge, is carefully applied for the painted eyebrows, around the eyes, and on the lips. This red tint is made from the *Benibana*, a red variety of chrysanthemum. Traditionally, a small mouth and reddish lips portray femininity, so that oshiroi is applied over the lips as well, a small, feminine mouth being painted last.
photo: Kishin Shinoyama

### #5 Torii: shrine gate
The traditional shinto gateway leading to a shrine makes a strong visual symbol with its four straight lines painted a vermilion red. Modeled after the monumental *torii*, these little red torii are tokens of pilgrims' monetary contributions to the shrine they have visited, Kyoto's famed Fushimi Inari. *Inari*, sacred white foxes, are the gods of the harvest and commercial success; shrines dedicated to them being found all over Japan. These small offering symbols appear to have been abandoned, but the piles of torii clearly illustrate just how financially successful this Inari shrine is, and how much it is respected by its devotees for the answering of their symbolic prayers and petitions for commercial prosperity.
photo: Yōichi Yamazaki

#### #6 Bukkaeri Marujuban: quick-change under-kimono

The burning soul-fires embroidered on this undergarment for the kabuki theater are based upon the Buddhist concept of fire as a means of burning away all sins. This garment is worn in the play "Narukami, the Thunder God," by a powerful priest who is eventually undone by a beautiful princess with whom he falls madly in love. Interestingly enough, this beautiful red pattern is not revealed until the very end of the play, but is covered by a pure white kimono before his fall from grace. There is an aesthetic sense in Japan respecting hidden beauty as being refined and elegant. The tendency to wear elaborate patterns and beautiful colors on the inside lining of the kimono and *haori* (kimono-style jacket) reflects this unseen bold display.
photo: Shigeru Ōkubo

#### #7 Janome-gasa: patterned umbrella

The traditional Japanese umbrella, *janome*, meaning snake's eye, is made of an oiled paper colored with red, blue or black dyes with an unpainted white concentric circle representing the shape of the snake's eye. Following a rainfall, it is lovely to see this design of umbrella opened to dry in the sun. A red janome-gasa is said to make the user more beautiful as its soft pink hue is reflected on the skin; at least, so I was told as a child. Another interesting fact is that the making of umbrellas was a common type of craftsmanship practiced by *rōnin samurai* (unemployed warriors) who were banished from their clans. Forbidden by their code to do manual labor, they were, however, able to make umbrellas and fans at home.
photo: Takeji Iwamiya

#### #8 Himōsen: red-felt blanket

Placed upon a bamboo bench and set in front of an inn or a restaurant, the *himōsen* seems to invite the traveler or passer-by to sit down and have some rest and refreshments. It is a kind of eye-catching indication of a shop where you can ask for tea. It is also used on the stage for musicians and singers. Utilized for outdoor tea ceremonies, cherry blossom viewing, or picnicking upon a green, grassy field, this red, thick felt blanket becomes a carpet designating a space for a feast or party. The use of this type of cloth must have begun during the *Muromachi* Period (1338—1573) by an aristocracy influenced by China and the importation of Chinese carpets. At the same time, the dyeing of these cloths was expensive, making it an elegant enjoyment.
photo: J-O Photo Room

#### #9 Urushi: lacquerware

*Urushi no aka* is the famous red lacquer of Japan. While there are many hues of red in the world, when one thinks of Japanese lacquerware and the color red, a particular hue comes to mind. A craft with a long history, the making of lacquerware products achieved a certain perfection during the *Edo* Period (1602—1867) due to the fact that some samurai clans recommended that their craftsmen specialize in urushi. Even today, these areas of Japan still produce the best quality lacquerware and the finest craftsmanship. This soup bowl is from *Wajima*, one of those areas in which lacquerware was encouraged and has thus flourished over the centuries. The pattern on the bowl is *aki no nana-kusa*, seven flowers of Autumn, a popular theme.
photo: Kidō Ushio

#### #10 Manju: steamed buns

Originally from China, *manjū* was well known as a delicious sweet, but it was not until the *Edo* period (1602—1867) when sugar prices were lowered that common citizens could enjoy this dessert-like bun with a sugar filling or stuffed with *an*, a reddish bean paste made from the sweet *azuki* bean. The manjū seen in this photograph are called kōhaku manjū, colored red and white. They are produced as gifts for a wide variety of occasions. Delicious with tea, or at a special ceremony, their red and white color symbolizes a celebratory event, *medetai* or happy and joyous feelings. This feeling seems to extend from the maker to the purchaser; from the receiver to the guests, who actually consume this attractive gift.
photo: Takeji Iwamiya

#### #11 Shibori: tie-dye

The technique of tie-dye can be seen in many different countries around the world including China, India, Africa and South America. To begin with, it is a fairly simple technique consisting of knots of undyed fabric being tied or wrapped tightly with thread before the dyeing process. When the knots are undone, the original fabric remains undyed. However, *kyōkanoko*, a silken tie-dye technique from Kyoto is famed for its intricate, delicate, and extraordinarily fine craftsmanship. It was developed during the Edo Period's *Kan-Mon* Era (1661—1681) when kimonos were decorated with a combination of tie-dye and embroidery techniques. You can easily imagine the gorgeousness of these garments and the tremendous prices they commanded.
photo: Takeshi Fujimori

#### #12 Momen: cotton lining fabric

Next, we turn from silk to Japanese cotton. It is seen here in a contemporary clothing design created by Issey Miyake. This scarlet-red cotton outfit was shown in Issey's 1976 collection. The fabric he has chosen to use is a particular kind of *hanairo-momen*, flowery colored cotton, that the traditional kimono industry designers are uninterested in since it has long been used for kimono lining and cannot be thought of in any other way by these people. Once a contemporary mind turns its interest to style and clothing for society, a wealth of design concepts for the birth of stunningly modern fashions can be found in the sturdy, time-proven wear of the Japanese worker. The same can be said of these long-wearing fabrics.
photo: Noriaki Yokosuka

#### #13 In: seal

The formal seal to a Japanese is exactly the same as a signature is to a Westerner; it authenticates and identifies a person. These seals are registered with a city office so that their design can be legally documented for official use on such papers as financial statements, certificates, etc. Such *in*, when registered, are called *jitsu-in*, legal seals, and are treated as authorized signatures; causing tremendous problems if ever lost! The interesting ones shown here are by the artist Bakusan Sakaki, whose stylization of the characters makes each one outstandingly unique and beautiful. The traditional ink used, *shuniku*, a vermilion colored ink, when stamped on white washi paper produces a typical Japanese red and white combination.

#### #14 Ōiri-bukuro: success envelope

This is an excellent example of the Japanese use of kōhaku, red and white combination. The red envelope with two white-reverse characters which read (from top to bottom), *Ō* or big, and *iri* or admission, actually mean that there have been so many customers that the management wants to express its appreciation with a small financial payment to be found inside the congratulatory envelope. This is presented to all of the employees. Originally a popular tradition in the theatre world when a performance was a financial success, it was a way for the producers to

share their joy with the members of the theatre troupe and influencial supporters from the audience. However, today it is used in a variety of commercial organizations.
photo: Yōichi Yamazaki

#### #15  Daruma: Boddhidharma
As the twenty-eighth patriarch in apostolic succession of Buddha Gautama, the 6th century *Daruma* taught that enlightenment is to be found through the heart and sought in silent meditation. He is said to have meditated for nine years before a blank wall, until his arms and legs became lifeless. His overcoming of pain and suffering inspires in others the belief that they too can overcome the worst disaster and prosper, achieving their dreams. These Daruma dolls are weighted at the bottom and will bounce back up if knocked over. They are purchased at temple and shrine festivals by people wishing luck or the fulfillment of their ambitions. Sold without painted eyes in Japan's eastern areas, one eye is painted with a wish, the other on fulfillment of it.
photo: Taishi Hirokawa

#### #16  Tako: kites
*Tako-age*, kite flying, became very popular during the Edo Period, making many technical advances. It was a game or sport enjoyed by nobility, samurai warriors, and commoners. Gradually, the subject matter and style of the famed *ukiyo-e* and *nishiki-e* woodblock prints were applied to *tako-e*, kite pictures, and they became more and more gorgeous, full of bright, lively action and color. Even today, the best examples of this folk art are painted by hand: first the black outlines, followed by the light colors and finally the vivid reds. This example was painted by Keizaburo Nakano from Tsugaru, Aomori Prefecture. In it, *Kintaro*, a legendary mountain boy, is nursing at his mother's white breast. His humorous red-faced expression is very unique.
photo: Takeji Iwamiya

#### #17  Hanafuda: flower cards
One deck of *hanafuda* consists of forty-eight cards, four cards for each month of the year and decorated with flowers, trees, and animals emblematic of that season. There are some 30 different games that can be played with one deck of hanafuda. Invented during the end of the Edo Period, it continues to be a popular pastime, often inviting monetary betting. These simple designs with red, white, black, brown and yellow are parts of my dearest childhood memories, when my grandmother would organize card parties for the entire family. I remember that we could collect cards in our hand according to the four general designs, the flower illustrations, or the highly decorated patterns which always

paid off with the highest number of points.
photo: Kidō Ushio

#### #18  Hanafuda: flower cards
Kiyoshi Awazu created this poster design using the traditional Japanese *hanafuda* (flower-card) as his inspiration. This is a good example of the contemporary designer observing the past and coming up with new work for graphic media expression. Birds and mountain boar in this poster are rendered in the traditional style, and the artist has produced it in the famed woodblock print technique (*hanga*).

#### #19  Yokoo-Hijikata-Hosoe Poster
This poster has the atmosphere of that period during the 1960's in Japan when so many, many counter-cultural phenomena were happening. At the bottom right of the poster are the three names of the important creators of that period: Tadanori Yokoo, graphic designer; Tatsumi Hijikata, dancer pictured on the fence; and Eiko Hosoe, photographer. Each of these three was an evangelist in his own profession. In the case of the poster's designer, Yokoo began to use the themes and motifs which were rejected by the western oriented designers at that time, such as the Japanese flags, the rising sun and handprints. This poster advertises Hosoe's photography exhibition of Hijikata' dance as well as being a poster for a Hijikata performance.

#### #20  Hakama: pleated culottes
Can the West dress East? This thought provoking concept and image was created by graphic designer, Eiko Ishioka, with the costume design of Issey Miyake. In order to symbolize Japanese color, Ishioka chose the red *hakama* often seen in Japanese Shinto Shrines worn by *miko*, young, female shrine performers of the sacred *kagura* dances. Ms. Faye Dunaway's elaborate clothing, headdress and make-up, together with that of the small children created a very contemporary and powerful image of Japan in posters, print media, and television advertising for the boutique department store concept promoted by PARCO.
photo: Kazumi Kurigami

#### #21  Ko-haku no Nawa: red-and-white rope
The festive red-and-white rope makes a strong graphic statement as a theme in Ikko Tanaka's print. He has produced a long series of images based upon the rope or cord concept. When I see this *ko-haku no nawa*, it reminds me of the kabuki theater's colored rope and *danmaku* as seen in photo #3, and of the deep background knowledge the artist has of this and other Japanese theatrical forms.

## GREEN

#### #22  Bonsai: dwarf-trees
For many years I didn't care for *bonsai*. These stunted trees seemed too artificial for me to appreciate as products of nature or whatever. The end product struck me as being in rather bad taste. However, recently I have become much more aware of the goals of bonsai lovers and the meaning behind these miniature tree creations. If they are well-shaped they can reflect a symbolic existence of Nature, and the nature of a Tree. I truly love the way our ancestors were able to capture the grandure of nature in their own small gardens or in the interior of their homes. *Matsu*, the pine, is a popular subject for this sort of treatment since it is regarded as a godly residence.
photo: Takeshi Fujimori

#### #23  Matsubame: pine backdrop
When the kabuki theatre performs dance dramas adapted from the much earlier *noh* theatre, they often utilize a backdrop with a painted pine tree to signify the source of the drama. The noh dramas were originally staged outdoors and the painted pine tree at the back of the noh stage also reflects this image of nature and the overriding presence of the gods. When this image is used by the kabuki, one has the impression that the noh is being popularized and that the kabuki is taking advantage of the noh's aristocratic, high-class refinement.
photo: Kakichi Hayashi

#### #24  Takebayashi: bamboo forest
In Japanese tradition there are said to be three green friends; they are the pine, bamboo and plum, *sho-chiku-bai*. These evergreens survive the severest winter-cold and cannot be dismissed from gala occasions, such as that of the wedding party, when the guests' tables are labeled *Matsu* (pine) for the bride and groom's families, *Take* (bamboo) for their friends, and *Ume* (plum) for friends of the family. Bamboo is revered for its ability to bend and yet bounce back even under the winter's heaviest snows. It is the symbol of enduring power. Most important, it is elegant looking, and, if I may dare say it, its shoots are just delicious during the early spring.
photo: Takeji Iwamiya

#### #25 Koke: moss
Tofukuji Temple in Kyoto is famous for its eight different gardens. One of them, this Ichimatsu "checkered" garden, was designed by Sanrei Shigemori as recent as 1938. Looking through the lens-eye of our photographer we can fully appreciate the designer's concept: creating a checkered texture out of the use of two, so different, materials, soft moss and hard rock. In addi-

tion, this juxtaposition makes a more effective color statement by bringing out the whiteness of the rocks upon the greenness of the moss, especially when viewed from the elevated position of the Hojo or priest's residence. A more traditional example can be found in Kyoto's Saiho-ji, also known as Moss Temple.
photo: Takeji Iwamiya

### #26 Katsuragaki: bamboo fence technique
This style of fence building was carried out at the 17th century emperor's detached palace just outside Kyoto, Katsura-rikyu. This marvel of Japanese traditional architecture is famed for its beautiful garden setting and villa layout. The *katsuragaki* technique consists of bamboo cut in half the long way and used to face each side of the small bamboo branch fencing material. Used within a well designed environment I feel that this type of fence does not block the view but becomes a part of the view and can be admired and appreciated for its colors and textures.
photo: Takeji Iwamiya

### #27 Aodake: green, freshly cut bamboo
*Aodake saibashi*, chopsticks (*hashi*) made of freshly cut bamboo are utilized for foods that are to be served off of one plate for all of the guests in a traditional Japanese menu. Notice the way that the joint is used in the shape of the chopsticks. In more chivalrous days gone by, the husband or host of a party would go to the bamboo forest before the arrival of the guests and prepare freshly cut bamboo chopsticks for their use during the meal. I wonder where those days have gone?
photo: Takeji Iwamiya

### #28 Oribe-yaki: Oribe pottery
When one sees this particularly beautiful green color on Japanese ceramics, they can be certain that it is *Oribe-yaki*. This type of ware takes its name from the famous 16th century tea master, Furuta Oribe, and it is distinguished by its characteristic green glaze, produced by the use of a liquid slip of copper. This square dish is a popular form of Oribe-yaki utilized for *kaiseki* cuisine, an extremely simple yet refined meal intended to accompany the formal tea ceremony. The plate was made by Kenzan Ogata, a famous ceramic artist of the middle Edo period (1650—1700), and is a rare work of art in that Kenzan had already established his own school of ceramic style but produced this plate in the Oribe style.
photo: Kidō Ushio

### #29 Sadō: tea ceremony
Tea leaves ground into a fine powder, mixed with hot water in a ceramic bowl, whipped, and drunk from the bowl. A simple statement but it hardly begins to explore the depths of esthetic manner to be found in the cult of tea. The proscribed rules for participation in the ceremony were perfected by Rikyū Sen in the Azuchi-Momoyama Period (late 15th century), having as their goal a well-mannered meeting of host and guest to appreciate the aroma and taste of the tea, the beauty of the tea bowl, and the simple, controlled nature of the room and its surroundings. When I was young, there were too many rules for me, but, today I enjoy its meditative, cleansing moments in our restlessly civilized world.
photo: Takeji Iwamiya

### #30 Mochigashi: rice cakes
These *mochigashi* are all made of pounded rice made into little cakes and stuffed with a sweet mixture of red *azuki* beans. These particular rice cakes reflect the subtle seasonal changes from late winter to early and late spring in the use of the leaves of the season: *tsubaki* or camellia, *sakura* or cherry, and *kashiwa* or oak. The tradition of using the most handy wrapping material (leaves) for flavoring or decorating your foods is easy to appreciate.
photo: Michikazu Sakai

### #31 Chimaki: wrapped and tied rice cake
Different from other wrapped rice cakes, these are tied into little individual bundles. This wrapped and tied style was originally utilized for preserving foods and is said to have come to Japan with islanders from the south as a part of their food preparation customs. The same technique can also be found in China, where they cook a glutinous rice with pork or shrimp. In Japan we have triangular shapes, square shapes and round

shapes for different kinds of ingredients. Square *chimaki* shapes are most often used for sweets. The wrapping leaves are of bamboo so that the distinctive flavor of the bamboo is added to the taste of the food, making it more delicious.
photo: Michikazu Sakai

### #32 Karakusa: vine pattern
Written in *kanji*, the Chinese characters which Japanese also use, *karakusa* means Chinese grass. This *moyō* or pattern is a stylization of the way that vines twist and curl, and is one of the most typical designs to be found in weaving, dyed cloth, and *maki-e*, lacquered ware patterns. *Furoshiki*, wrapping cloths, in this pattern have been so very popular in Japan's past that fashionable people don't like to be seen with it in their hands! It makes them look, they think, like runaway country bumpkins lost in the big city. There was a famous Japanese comedian who established his character by always appearing with a large karakusa furoshiki on his back.
photo: Yōichi Yamazaki

## Blue

### #33 Nihon-Kai: Japan Sea
Located to the west of Kyoto prefecture is the Tango Peninsula and the Japan Sea, photographed here under clear autumn skies. Takeji Iwamiya has produced book of photographs entitled "Japan Sea," in which the famed author Tsutomu Minakami writes: "Yomi-no-kuni exists over there; a land for those who have passed-on, there across the seas where the gods and buddhas dwell. Without a doubt, they come from somewhere across the ocean." The sea is their bed of eternal sleep, or so our ancestors believed. The sea is also the source of our daily foods such as fish and seaweed. On these pages we see the placing of fishing nets at sea, *okiami*. Japanese regard the sea as a watery field from which we gather the harvest, just as we would crops upon the land.
photo: Takeji Iwamiya

### #34 Tako Karakusa: octopus vine-pattern
A funny, but descriptive naming for this Imari ceramic pattern. The karakusa pattern is introduced on plate #32, but this particular example has short lines on each of the vines which remind people of octopus tentacles covered with suckers. Humorously, the pattern seems to be almost endless, continuing on and on. Imari ware is the name for ceramics made in the Arita kilns of Saga Prefecture, and distributed through the sea port of Imari. It has become popular to call this

pottery Imari ware rather than Arita ware.
photo: Kidō Ushio

#### #35 Soba-Choko: noodle soup cup
Before being eaten, wheat noodles are dipped into a special soup which has traditionally been held in a small cup called a *choko*. This style cup is one of the most sought after blue and white ceramic folkcraft pieces in today's society. Humble in origin, it now serves a double purpose as a tea cup for friends who enjoy folkcrafts, coming off the shelf, where it's probably on display, to be used and handled once again. A perfect size for the hand, the cup is decorated with simple, hand drawn patterns in *ai*, the cool blue which is so pleasing to the eye. There are many designs and collectors like to find matching or unique ones for their personal collections. One of the most popular kiln productions is called "old Imari."
photo: Yōichi Yamazaki

#### #36 Ai-zome: indigo dyeing
Recently there has been a revival of interest in *ai-zome* for *yukata*, cotton summer kimonos, and dressmaking fabric. *Shibori*, the tie-dye technique, has also flourished together with the popularity of indigo dyeing since they easily complement each other. After many years of frustration, seeing poor quality chemical color prints on young women's yukatas, it is refreshing to know that this kind of movement can take place. Perhaps it means that people will become more concerned with the texture quality and color sensitivity in kimono wear as well. Soft cotton tie-dye wear in ai-zome expresses everyday chic, while kyokanoko (see plate #11) is elaborate and elegant. The most famous shibori comes from Arimatsu, an area near the city of Nagoya.
photo: Kō Fujimoto

#### #37 Shima: stripes
If you know a little bit about the history of stripes in Japanese clothing you will certainly understand why their expression is so rich and varied in woven fabrics. Going back into the late 18th century in *Edo*, present day Tokyo, we find that the citizens were very much taken by stripes. Wealthy citizens who wished to express their monetary power through clothing were denied fancy dress by the *samurai* lords. Their zest was therefore poured into well-designed, artistically subtle stripes which did not look gorgeous or extravagant on first glance, but were full of beautiful hues and color combinations with indigo blue. It is said that kimonos begin and end with stripes.

#### #38 E-Gasuri: figurative ikat weaving
This traditional *sumo* wrestler was woven in the *kasuri* technique of splashed patterns. It was found in Matsuyama, on the Japanese island of Shikoku. Subject matter for kasuri is usually geometric patterns, plants, animals, or scenery. It is very rare to find such a well composed human being, especially with such a humorous touch. Critically viewed, it is an example of kitch kasuri, but it's adorable. I love to imagine the woman who created this design and then wove it (the creation of kasuri is primarily a woman's craft); she must have had some particular sumo wrestler of that period in mind when she planned this design. I wonder who it was?
photo: Yōichi Yamazaki

#### #39 Noren: door curtain
This practical curtain serves to prevent dust, cut glare, and mask the entrance from the eyes of curious strangers. It also denotes a shop or a business since it's often hung in front of a commercial establishment to symbolize that they are now open for business. Used as this type of sign, the *noren* is normally ai colored or brown, with white letters for the business name, logo mark or house crest. The expresssion "to share the noren" means that the owner is helping one of his ex-employees to set up their own related business after a long apprenticeship.
photo: Takeji Iwamiya

#### #40 Sashiko: quilt stitching
Originally begun as a means to strengthen or repair parts of clothing that receive heavy duty wear, this stitching technique developed over the years into a much admired folk art. Indigo dyed cotton threads stitched on a thick white cotton fabric, or the reverse, is a simple yet powerful decorative effect. It was during the Edo period that firemen began to use these thick sashiko jackets as their uniform. The tradition of wearing this strong fabric can still be seen today in the jackets for judō and kendō atheletic competitions.
photo: Kidō Ushio

#### #41 Irezumi: tattoo
Tattoos in Japan reflect the wearer's spiritual devotion and are often dedicated to a special deity or in memory of someone. Mr. Ōwada, the man in this photograph, has dedicated his body totally to the muse, or the god of crafts. The ability to endure the long hours and the pain necessary to complete such a tattooing work of art seems to be a very masculine test; only appreciated fully by other men. I vividly remember one Sunday morning when several close friends of mine gathered to visit Mr. Ōwada and other tattooed enthusiasts, when I was informed that a woman could not be included in the group. So, I was excluded and my imagination became more and more stimulated.     photo: Kidō Ushio

#### #42 Ao no Rensaku: Series in Blue
The artist Kazumasa Nagai has, for several years, been exploring various techniques in which to express his fascination with geometric images. Highly successful with embossed white paper creations, he is now drawing his images on paper in the most basic of human expressions with paper and pencil.

# BLACK

#### #43 Kanji: Chinese pictograph
This *kanji* character translates as mountain and is pronounced *yama, san* or *zan*. As a pictograph it represents three mountain peaks, the one in the center being the highest. It was written with an inked brush and is an excellent example of good Japanese calligraphy; this example coming from the prestigious Daitoku-ji temple in Kyoto. In the original, there is another character written in conjunction with this one forming the word *kanzan*, which means the four surrounding mountain areas in the country in which you were born. The high-priest who selected the word *kanzan* for his calligraphic art was thus able to suggest such a scene to the viewer, reminding them of nature's beauty in their own home town.
photo: Yōichi Yamazaki

Poster. Design by Ryuichi Yamashiro, 1955

#### #44  Keshiki: landscape
Climate seems to me to be a determining factor in the esthetic appreciation of any nation's people. Especially looking at Japan's layer upon layer of mountain scenery, I become aware of the moisture-produced mists which hang upon the mountain top, resulting in landscape views reminiscent of *suiboku-sansui* genre paintings. These black and white landscape paintings are typical of Japanese artistic expression. The four characters used to write sui/boku/san/sui translate as: water/India ink/mountain/water.
photo: Shinzō Maeda

#### #45  Mofuku: mourning clothes
There is an old *senryū* (playful *haiku* poem) which says, "Even old wives/look fetchingly beautiful/at the funeral wake." Some of my more black-humored friends say, "I would like to see my wife in her mourning kimono at my funeral." The reason for these droll sayings stems from the fact that this black, simple kimono has a somber beauty which is very striking, and the woman wearing it in such a tragic situation appears to be more beautiful than the shallow beauty of everyday life. Dressed in a solid black silk kimono with the contrasting white family crest, over a silken under-kimono and white *eri* or collar, the garment is completed with a heavily brocaded black silk *obi* or sash, and white *tabi* (cotton footwear).
photo: Kidō Ushio

#### #46  Geta: wooden clogs
The wearing of *geta* also became popular during the Edo period. The material used should be light-weight but strong. For this reason, *kiri* (paulownia) and *sugi* (cedar) are the most popular woods chosen. Black lacquered geta with white straps (*hanao*) are elegant for men. The lacquered paulownia clogs are without a doubt the most expensive, but they are also the most beautiful. The black lacquer makes the foot look very attractive, either bare or with cotton tabi. The barefooted look with geta goes well with a *yukata*, the summery cotton kimono.
photo: Takeji Iwamiya

#### #47  Kawara: roof-tiles
When the British art critic, Herbert Reed, visited Kyoto some years ago, it was said that he was most impressed by the view of the old capital from a high hillside. It was the month of May and many houses were flying carp banners of various colors over their roofs in honor of Boy's Day. His strong image of Kyoto as an active grey sea with red female and black male carp swimming happily in the sunlight can be easily imagined. It is an image created by our ancestors for us today. Sadly, the use of authentic *kawara* is dying

out and old cities like cultural Kyoto are becoming similar to new cities anywhere in Japan. The smokey greys of the old tiles were obtained by burning pine needles in the kiln. Today, the new tiles look like shiny, brightly colored plastic.
illustration: Takashi Yamamoto

#### #48  Namako Kabe: diagonal tile wall
This is another of those traditional building designs which is being lost in contemporary society. Square-flat kawara tiles are placed diagonally on the exterior wall of a storehouse or *kura*, with a thick layer of white plaster placed around the edges of each tile. Both the tiles and the thick plaster help to protect the wall (*kabe*) from heavy rain or violent damage. The rounded strips of plaster are said to have reminded the workers of long sea cucumbers, *namako*, hence the origin of this strange name. This particular photograph is of a kura wall in Kurashiki City.
photo: Kidō Ushio

#### #49  Sumō-e: wrestler pictures
In addition to the Japanese beauties found in the *ukiyo-e* (floating world pictures), there are many imaginative drawings and woodblock prints of powerful *sumō* wrestlers. Important wrestlers' faces are of course featured, as well as scenes from their activities within the ring. This wrestler's black and white apron is called a *mawashi* and is a decorative ornament for the *yokozuna* (grand champion) to wear when he first enters the arena. Usually the mawashi is gaudily colorful, but this *hanga* or print captures our interest with the unique design sense of the wrestler or of the artist.

#### #50  Seifuku: uniforms
*Gakuseifuku*, the student uniform, is a very good example of Japan's clothing culture for the masses. The type of uniform in this photograph is worn by junior-high and high school boys, while the *jo-gakuseifuku* (girls' student uniform) is patterned after a navy sailor's outfit. Someone has said that the reason Japanese boys like to wear a uniform is that it's simple and easy to wear day after day and it eliminates individual competition. As one who dislikes conformity, I love this parody of the students' black uniform done in white for women by Issey Miyake. The original black stand-collar suit with metallic buttons reminiscent of military uniforms was adopted in 1886 by the Imperial University and soon became the accepted uniform at other colleges and lower grade schools.
photo: Kishin Shinoyama

#### #51  Monshō: family crest
The use of the family crest began in Japan during the 11th century when aristocratic

nobles designed them in a favored pattern to be applied to their personal belongings. The samurai warriors began to use their family crests in this way during the early Kamakura period (14th century), and the wealthy merchants of the later Edo period also copied this tradition. After the Meiji Restoration (1868) the class system was abolished and every family was allowed to have their own crest. At the present time, people are becoming interested in their family tree and we are seeing a growing interest in family crests.
photo: Yōichi Yamazaki

#### #52—60  Trademark, logo
The esthetic sense of family crest design is as fascinating as the contemporary campaign for the establishment of corporate identity.
(left to right)
Asahi Culture Center by Shigeo Fukuda
Good Design mark by Yusaku Kamekura
Meiji Centennial by Tadashi Ōhashi
Osaka Hotel Plaza by Yōshio Hayakawa
Suruga Bank by Kazumasa Nagai
Yamagiwa Electrics by Yūsaku Kamekura
Mikami Company by Hiroshi Kōjitani
Ocean Expo, Okinawa by Kazumasa Nagai
Asahi Mutual Life Insurance Co. by Ikkō Tanaka

#### #61  Kantei-ryu: kantei style lettering
December in Kyoto is a month of special preparations for the new year and a time when you will see dozens of signs and banners in this bold, characteristic calligraphic style called *Kantei-ryu* after the 1779 professional sign painter who began this writing style for poster displays in front of the kabuki theaters. Kantei style was originally used to write out the name of plays being performed in the Kabuki theater, where it is still used for play titles and actor's names. This bamboo and pine wood installation in front of a theater is called a *maneki*, invitation, and lists the main actors' names for a *kaomise* (face-showing) performance by the leading stars.
photo: Takeji Iwamiya

#### #62—66  Moji: letters
Creative and highly inventive lettering designs are very popular in Japan and seem to spring up all around us everyday. In our own writing system we utilize and read daily three different systems of characters: *kanji*, pictographs borrowed from Han Dynasty China; *katakana*, a phonetic alphabet of simplified kanji; and *hiragana*, a script-like phonetic alphabet. Designers like to express their clients' image through creative lettering.
(top to bottom)
Hakone Park Aquarium by Tadasu Fukano
You Ain't Heard Nothin' Yet by Makoto Wada
Graphic (Work Exhibition) by Yasaburō

Kuwayama
Kurabera synthetics by Tadasu Fukano
Skylark (the name of a restaurant chain) by
Kō Nagashima.

#### #67 Otoko to Onna: man and woman
The artist/graphic designer Shigeo Fukuda is
one of those rare Japanese creators who are
fascinated with humor in all forms of artistic
expression. This work is described as an egg
from Columbus, a new discovery. In it he
entertains us with a totally unexpected visual
image.

# GOLD

#### #68 Kogane no Nami: golden waves
As the rising sun sends its warming rays to
strike the bountiful crops in the rice-paddy,
the golden grains sparkle, responding to the
slightest breeze. The quality of the coming
harvest can easily be judged by the heavy
way in which the rice-straw weights down the
long grassy plant tops. Autumn is synony-
mous with the harvest; the ripened crops
being the fruits of our labor and the miracle of
nature. Seeing these images of ripening rice
in the countryside, you can better understand
the way that Japanese feel towards their
staple food.
photo: Taikichi Irie

#### #69 Mikoshi: portable shrine
Written in kanji characters, mikoshi trans-
lates as God's chariot. The first document
which mentions a mikoshi is dated 945 A.D.
During the Autumn we like to celebrate a
successful harvest by carrying the spirit of
the gods in the mikoshi around the neighbor-
hood. Young children have their small porta-
ble shrines and participate in charmingly
cute parades. Meanwhile, the young men
(and sometimes women) celebrate in a
wilder, more enthusiastic demonstration of
group excitement. Sometimes two different
mikoshi will come together in a challenge-
like duel of pushing and shoving. It can
become frightening. The mikoshi itself is a
work of decorative carving art; painted gold,
it symbolizes the citizen's gratitude towards
the gods of the harvest.
photo: Yūzō Yamada (Bon Color)

#### #70 Kai-awase: gold-shell game
Begun in the Heian period (8th to 12th centu-
ries) the game of matching old-shell painti-
ries was very popular among the aristocracy.
Originally they would write poems on the
shells, judging whose lyric made the most
beautiful, elegant song. Later centuries saw
the game evolve into a matching competition,
finding the same theme or subject matter

among the various shells. These ancient
shells, beautifully painted on a gold base,
are now prized treasures, along with the six-
sided containers for holding these examples
of centuries old craftsmanship and artistry.
photo: Takeshi Fujimori

#### #71 Maki-e: gold inlay
This is a detail shot of a maki-e decorated box
from the Momoyama period (1573—1602).
The design is of aki no nana-kusa, the seven
grasses of Autumn. There are also seven
Spring grasses often utilized in this type of
art. The Spring grasses are selected from the
common weed-like flowers and grasses
which used to be found everywhere. How-
ever, as our environment has changed we are
only able to find these plants growing wild in
the deepest mountain valleys, or in some city
flower shop. The maki-e technique and the
thematic design of the grasses produce an
outstanding example of Japanese crafts-
manship.
photo: Kido Ushio

#### #72 Byōbu: folding screens
Tagasode, whose sleeves? ... as a title for this
screen painting, isn't it an enchanting name?
The idea of painting kimonos on a rack with
gold screens in the foreground of these gold
screens (kin-byobu) is fantastic. It suggests
that we try to imagine who and where are the
ladies that wore such stylish kimono of that
period. It is interesting to note that textile arts
had made rapid progress during the
Momoyama period (16th and 17th centuries)
and had prepared the way for Edo's citizens
to begin to enjoy the blossoming of Japan's
kimono culture. Screens such as this one
also were admired by the populace but were
only available to the nobles and samurai
class. At the present time, decorative byōbu
are rarely used, undecorated gold screens
being used for festive occasions such as wed-
ding ceremonies, serving as the backdrop for
the bride and groom to greet and thank the
guests.
credit: Suntory Museum

#### #73 Mai Ōgi: dance fan
Fans are one of the most important proper-
ties on the stage for a Japanese dance perfor-
mance. Other props are held to a bare
minimum, with the fan taking the place of
almost all items that you can imagine: a
sword, leaf, sake cup, bottle, wheel, a river,
etc. On the limited space available for design
on this fan, it is amazing to see the incredible
amount of energy being displayed by the
wild, stormy ocean in this compact, closed-in
area. It reminds us that Japanese also regard
the inside of the teabowl as an ocean.
photo: Takeji Iwamiya

#### #74 Ōban Koban: large and small gold coins
From the medieval age to the beginning of a
modern Japan, this type of gold coin was the
currency of the realm. This type is called kei-
chō ōban and was valid from 1601 to 1695. It
is approximately 15-centimeters long while
the smaller keichō koban is 7-centimeters in
length. The large coins were used for repay-
ment of a debt, compensation, or for a
reward. The smaller ones being used for every-
day currency. The large coins with black
sumi writing on them supposedly reflect the
authoritative air necessary for a reward.
photo: Takeji Iwamiya

#### #75 Butsudan: Buddhist altar
A highly decorated Buddhist altar intended
for home use. It's as if the believers want to
see gokuraku or paradise on earth, and can
also be observed in religious structures and
retreats. Before the war, almost all Japanese
families possessed butsudan at home. It pro-
vided the family with the feeling of closeness
with their ancestors and was highly regarded
by the older generation. I can recall my
grandmother making me sit in front of the
altar with a lighted candle flickering dimly
and mysteriously. It made me behave and feel
that I should make an apology to my ances-
tors. If it was not religious education it cer-
tainly made a strong religious impression.
photo: Takashi Hatakeyama

#### #76 Mizuhiki: decorative paper cords
These are utilized for gift packaging. The
mizuhiki seen here are specifically for the
decoration of wedding engagement gifts.
The crane and turtle design (tsuru-kame) is
very auspicious in Japan, relating to long life
according to ancient legends. The cords are
colored silver and gold or red and white for
happy occasions; pure white, black and
white, or blue and white for solemn events.
photo: Takeji Iwamiya

#### #77 Jamon: snakeskin pattern
In Japan, the use of the color gold has a very
strong tendency to become kitch and gaudy.
But here, Kansai Yamamoto has produced a
garment of good design using gold knit. Jap-
anese fashion design taste, after decades of
blindly following European trends, has
found its own way to creatively add some-
thing to the world of design: quite naturally
making use of Japan's traditions in a blend
with leading edge design sensibility. When I
see this traditional pattern of stacked trian-
gles, symbolic of the skin of a snake in the
noh and kabuki costumes, I feel that it
doesn't matter if Kansai used its meaning
consciously or not.
photo: Noriaki Yokosuka

### #78 Dentō Engeki: traditional theatre arts

A project involving various forms of Japan's *dentō engeki* in performances across the United States: Los Angeles, Washington, D.C., and New York. 12 famous graphic designers also participated in the project, providing posters and art work in support of the friendship tour. This poster is for a program of *Nihon Buyō*, classical Japanese dance, and was designed by Yūsaku Kamekura.

## Multi-colored.

### #79 Hana to Shimenawa: flowers and straw rope

The *shimenawa* designates those places in which the gods dwell or are worshipped, and therefore are sacred precincts. Especially during the New Year holidays, Japanese people decorate their homes with some sort of rope made of straw to welcome the new gods into each home and to renew the vital source of the family spirit. This type of specially made straw rope is used at *Shinto* shrines and at particular places within the home. It serves to separate the inner, sacred or pure area, from the external, mundane atmosphere of everyday life. Floral offerings, such as this New Years' arrangement, are often presented at the local shrine and look beautiful in juxtaposition with the rope of rice-straw, symbolizing Japan's rice culture connection.
photo: Takeji Iwamiya

### #80 Hina-Ningyō: doll set

March third is *hina-matsuri*, doll festival, and is celebrated by each family with young girls. They place their treasured family heirloom dolls on a step-like platform for the appreciation of guests and friends of the girls. Often the *hina* dolls are dressed in the attire of the *Heian* period (794—1191) court ladies; hair styles, ornaments, and kimono coloring showing a distinct Chinese influence. The kimono style worn here is called *jūnihitoe* meaning 12-layered. While there may not be exactly 12 kimonos worn, the meaning is that there are many under-kimonos one on top of the other. The essential hina-ninygo set consists of a king and queen, three court ladies, and five noblemen playing musical instruments. They are displayed from the end of February.
photo: Takeji Iwamiya

### #81 Hi-Gashi: dry confectionery

As the Japanese truly care for nature and the visual changes of the season, we have dried sweets which conform to the feeling and colors of the four seasons. The smallest phenomenon, flowers, leaves, animals, can serve as a theme of nature for something designed to eat. One of the reasons that these small cakes are so visually beautiful is that their production has grown and prospered due to their use in the tea ceremony. In sadō, the use of objects and edibles of refined beauty is greatly admired, bringing praise and attention to the host or hostess of the gathering.
photo: Takeshi Fujimori

### #82 Kachō-mon: flower and bird pattern

The *kachō-mon* is one of the most popular motifs in all Japanese ceramic art. In this example, early Edo ceramics serve as the inspiration for a reproduction reflecting the genius of the original. It was produced by the thirteenth generation master of the same Kakiemon kiln who notes that extreme care must be taken when drawing the pattern as on the original; judging the thinness of lines which have gently and exquisitely faded over the years, adding a gentle flavor to the pattern. This *fukabachi* or deep bowl shape originally had a lid as well.
photo: Chūji Minematsu

### #83 Temari: handball

The beginning of a well-known childrens' song goes, "ten, ten, temmari, ten temari," using the rhythmic sounds of the lyric to imitate the bouncing of the *temari*. When I hear this song I automatically see the handmade ball of silken thread with its geometric patterns. One can imagine a little princess playing with silk thread temari while the Edo city children play with their cotton ones, all made by the loving hands of mothers and grandmothers. The craft is still preserved in the country where you often come across these decorative joys in antique or craft shops.
photo: Takeji Iwamiya

### #84 Yūzen: resist dyeing

A technique of creating picturesque patterns or images on silk that was begun by the Edo Period dye printer Yūzen Miyazaki. Historically his name has become the general term used to describe this technique of applying starch to the fabric in order to resist the dye, preventing it from coloring the desired reverse pattern. Today, old examples of Yūzen are very stimulating to people of creative taste. It was from this stimulation that Shinya Fujiwara's photography was born.

### #85 Maiwai: fisherman's celebration robe

Fishing villages have a tradition whereby the owner of a ship rewards his fishermen for their bountiful catch. This decorative *maiwai* takes its name from *ma(n)*, meaning ten-thousand or "endless", and *iwai*, meaning celebration. The two Japanese words blended in pronunciation. This tradition began, it is said, after a famous fisherman was able to gather some ten-thousand bushel baskets of dried sardines, and was presented with this type of robe by the ship owner in acknowledgement of his deepest appreciation. Included on the *maiwai* are, the name of the ship, straw rope pattern, family or business crest, together with festive images of the crane, turtle, pine, bamboo and plum; all produced in a multi-color dyeing technique. Worn as an easy jacket it is very masculine.
photo: Takeshi Fujimori

### #86 Tairyō-Bata: celebration fishing flag

Fishermen have traditionally flown decorative flags to announce their success upon return to port. At the present time the tradition has been expanded to include decoration for festive occasions such as the first fishing of the New Year, visits to the Shintō shrine for a blessing, or the launching of a new ship. The many graphic designs used include noshi, tsuru-kame, hi-no-de (rising sun) and some 50 other popular patterns produced in highly colored graphics on cotton. The maiwai designs also seem to have strongly influenced contemporary fishing flag patterns.
photo: Takeji Iwamiya

### #87 Senbazuru: thousand cranes

The *origami* folded paper technique is most often utilized for the making of the crane. During the Edo Period there was a book on origami published detailing the steps necessary to fold a paper crane, dated 1797. The strands of cranes here, numbering one-thousand, are tied with strings like the Hawaiian flower lei and are hung in shrines and temples to signify the sincerity of their wish or prayer. It is certainly an example of their devoted efforts. The individual folded crane looks neat and clean, crisp and ready

to fly. How different is the feeling given by these strand after strand of *senbazuru*, a busy, shamanistic image of days long gone by, yet still here.

photo: Takeji Iwamiya

#### #88 Chiyogami: woodblock printed paper
During the late Edo Period, young girls and women used to play with patterned paper to make dolls, boxes, and many other items of entertainment and decoration. Looking at the high quality of woodblock printing evident in these sheets of paper it is easy to believe that the ukiyo-e print artists were the suppliers of *chiyogami*, meaning literally thousands-of-years-paper and referring to the fun, happy celebratory atmosphere created by the bright patterns. Viewed individually, one would imagine that these busy patterns would not work together, but, interestingly enough, they form a harmonized image of Japan. At the specialty shop Isetatsu, the old print woodblocks and special quality paper are still used to this day.

photo: Yōichi Yamazaki

#### #89 Nebuta: float lantern
The wildly ferocious lantern painting and construction craft, while primitive, is strong and impressive. These huge *nebuta* are made for a festival in northern Japan and are paraded at the beginning of the *Obon* season, when the souls of the dead return to their former homes. The word nebuta sounds like "*nemutai*," meaning sleepy. In conjunction with this, it is said that if people wipe their sleepy eyes with leaves from a tree and then toss them into a river, their sleepiness will also be banished. The nebuta seems to be used in the same way, as they throw this powerful work of handicraft away the cele-brants feel that they are now discarding their sins as well and will thus be able to meet their returning ancestors pure and free from worldly sins.

photo: Takashi Hatakeyama

#### #90 Hanawa: flower wreath
If one were to begin looking for an example of Japanese kitch taste, I would immediately recommend a visit to Tokyo's downtown market place where one can find gaudily colored ornaments, decorations, and this flower wreath. The *hanawa* is a gift or offering symbol in which flowers, fresh or made of paper, are fashioned into a wreath and installed on a standing frame which is placed in front of a theater, new store, or home. It is most often used for festive occasions but can also be seen in black and white color combinations at funerals. The brightest, most gaudy hanawa are normally lined up in front of *pachinko* pinball parlors.

photo: Taishi Hirokawa

#### #91 Kumade: bamboo rake
Anyone involved in a trade dealing with customers, like a restaurant or a bar, wishing for good luck during the coming year feels the need to purchase an ornamental, highly decorated bamboo rake with which to rake-in good fortune. These *kumade*, meaning bear claw, are decorated with all types of symbolic omens of wealth, luck, and good fortune: miniature rice bales, bamboo, pine, plum, gold coins, the seven gods of luck (*shichi-fuku-jin*), and the famed treasure ship (*takarabune*). Arrows in a bull's-eye, the *tai* or sea-bream, a very fortuitous fish, masks and *shimenawa* (straw ropes) are also used in decorating these rakes to the extreme of kitch, making it difficult to understand how sober establishments can prominently display them in all seriousness. But they make wonderful decorations!

photo: Kenichi Samura

#### #92 Men: mask
Every culture in the world has its own special design for masks: Greek masks, Tutankhamen's gold mask, warrior's armor masks, the commedia dell'arte character masks, to mention just a few. While Japanese theatrical masks range from the early Gigaku and Bugaku forms to the highly refined Noh masks, contemporary tastes are highly influenced by television programs so that plastic, brightly colored masks of robots and monsters can be seen on any walk through the sidewalk stalls at a Japanese festival.

photo: Taishi Hirokawa

#### #93 Ebisu-Ichi: god of wealth festival
While the people of the eastern *kanto* area of Japan celebrate *tori-no-ichi* (festival of the bird) with sales of the kumate bamboo rake, the citizens of western *kansai* areas have their festival dedicated to the god of wealth, Ebisu. In the kansai, small stalls or *yatai* are also constructed on the grounds of the temple or shrine where the festival is located but the decorative ornaments are different in design, reflecting the difference in taste between the eastern and western people of Japan.

photo: Taishi Hirokawa

#### #94 Neon-Gai: city lights
The popular word for a neon sign in Japanese is simply *ne-on* (pronounced nay-ohn). Neon gai, *gai* meaning street, is the name for an entertainment street or district in which you see sign on top of sign, advertising that this building is a *baa-biru*, a building full of bars. The signs are lined up in a row along the edge of the building. You will see signs in Japanese (hiragana, katakana, kanji), English, French, Italian, and even Dutch. The colors are bold and in contrast with each

other. This type of sign has nothing to do with the so-called Japanese tradition of good taste. At one glimpse it is obvious that confusion reigns, and I think this scene is symbolic of one face of Japan today. If there is anything to appreciate here, it is the unmistakable vitality present.

photo: Yoshio Niikura (Bon Color)

#### #95 Fashion Live Theatre
This installation design was created on the occasion of Kobe City's Port-Island Expo (Portopia '81). It was a result of the energy and drive of five innovators: Yasuhiro Hamano, general producer; Tadao Ando, architect; Shiro Kuramata and Masanori Umeda, designers; and Issey Miyake, fashion designer, who supervised seven young clothing designers who were then sent to various countries around the world that were still relatively untouched by western influences. Inspired by their new experiences, these young people presented their impressionist creations.

photo: Yoshio Shiratori

#### #96 Zen Perfume
Makoto Nakamura's poster for Shiseido Cosmetic Company's perfume *Zen* (Buddhist enlightenment through meditation), presents an image which says in copy: "the most seductive scent comes from the most innocent of all." The creator has used kanoko tie-dye (plate #11) for the seductive-innocent image with famed model, Sayoko Yamaguchi expressing this complicated state of mind.

photo: Noriaki Yokosuka

#### #97  Window Decoration
Ryōko Ishioka is a graphic designer who is very skillful at creating her new images by combining different techniques. This one was presented in the large street window in front of Seibu Department Store so that pedestrians passing the window could enjoy this new art of expression.

#### #98  Book/Magazine Cover
Kōichi Satō's design for the special edition of Idea Magazine, dedicated to the activities of Tokyo Designers' Space, an independent organization made up of designers, writers, photographers, and other professionals.

#### #99  Poster
Theme poster for the Third Annual Japan Industrial Design Conference, designed by Mitsuo Katsui.

#### #100  Book Jacket Design
This very American-oriented designer calls himself "Terry," although his real name is Teruhiko Yumura. Despite his strong feeling for the American comic book drawing style, here he is enjoying the use of the kabuki theatre's famous five-wild-men, *shiranami gonin otoko*. This was produced for the cover of the Japan Illustrators' Annual.

#### #101  Illustration
Yōsuke Kawamura's illustration clearly shows the well conceived and stylized expression of Japan's fabled storybook character: the strong mountain boy, Kintaro. There is also a candy bar produced which when cut, amazingly shows his face inside. It is very popular with children at temple and shrine fairs.

#### #102  Avant-garde Theatre Poster
This poster for an avant-garde theatre troupe drama about the ancient samurai warriors, presenting a fairly violent image, was designed by the studio called K², consisting of Seitarō Kuroda and Keisuke Nagatomo.

#### #103  Image Poster
Harumi Yamaguchi made this illustration for a boutique department store called Parco. The poster copy says, "Can the Parco Feeling be Inherited or Not?" It must represent one of the very rare cases of a proud Japanese pregnancy, which is usually shy and secluded.

#### #104  Electric Pressing Poster
Katsumi Asaba draws our attention to the benefits of using an electric iron to press trousers. To highlight the situation, he has selected a kabuki actor who orders the black dressed (meaning invisible) *kuroko* stage assistant, which becomes the hidden, invisible help of our electric appliances.

#### #105  Cassette Tape Poster
Takahisa Kamijō's image of YMO, Yellow Magic Orchestra, is one of multiple pictures of the musical artists. YMO is the most successful Japanese group on the international scene.

#### #106  Movie Poster
Tsunehisa Kimura designed this poster to announce the first new movie by the famous film director, Seijun Suzuki, breaking a ten-year self-imposed silence. Frustrated by the situation within the Japanese film industry (out of which he graduated), Seijun decided to present his films in a small tent movie hall with funding from a relatively unknown film producer. His motion picture has been a tremendous success, winning many film awards including the Berlin Film Festival's International Art Film Award.

#### #107  Television Commercials
In one school of thought, a short commercial film is like a 30-second, or less, drama. With this philosophy, there have been many exciting ideas explored utilizing this media. It is interesting to note that increasingly, more and more advertising budget expenditures are being disbursed to the television media Creative people who are involved in this work are inspired by the combination of technology and artistic expression.
photo: Yoshinobu Aikawa

**Acknowledgements:**
We would like to express our sincere thanks
and deepest appreciation to the people and
organizations listed below who have lent their
film, photographic prints, or private art
collections for the preparation of this book.
Without their cooperation and deep level of
understanding, this project could not have
been completed.

Dai-ichi Shuppan Center Co., Ltd.
The Fujin Gahosha
graphic design associates
Heibonsha publishers, Ltd.
Ikko Tanaka Design Studio
Japan Center for International Exchange
Japan Interior Design Magazine
Kitchen
Hideyuki Oka
Komei Owada
Parco
Urano Riichi Collection
Ryuko Tsushin Magazine
Bakusan Sakaki
Sanpō-dō, Kyoto
Seibundo Shinkosha Publishing Co., Ltd.
Shufu no tomo Co., Ltd.
Sun-Ad Company, Ltd.
Suntory Museum
Takeda Kahei Shoten